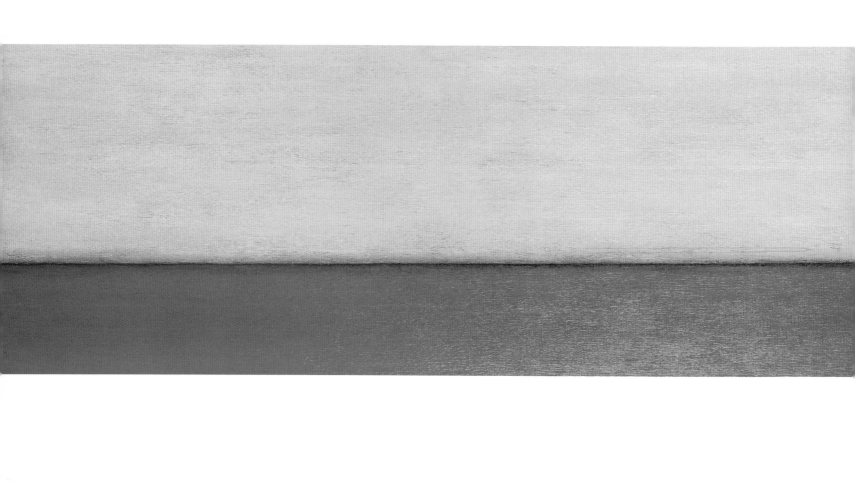

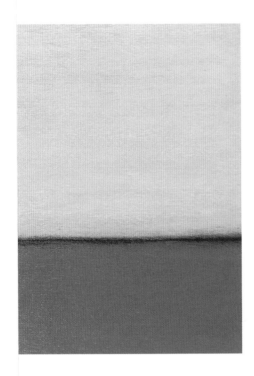

Tobi Kahn

Sacred Spaces for the
21st Century

Edited by Ena Giurescu Heller

With contributions by
Jeff Edwards, Ena G. Heller, Tobi Kahn,
David Morgan, Klaus Ottmann, Nessa Rapoport,
and Daniel Sperber

MUSEUM OF BIBLICAL ART
MOBIA g

Museum of Biblical Art, New York
in association with D Giles Limited, London

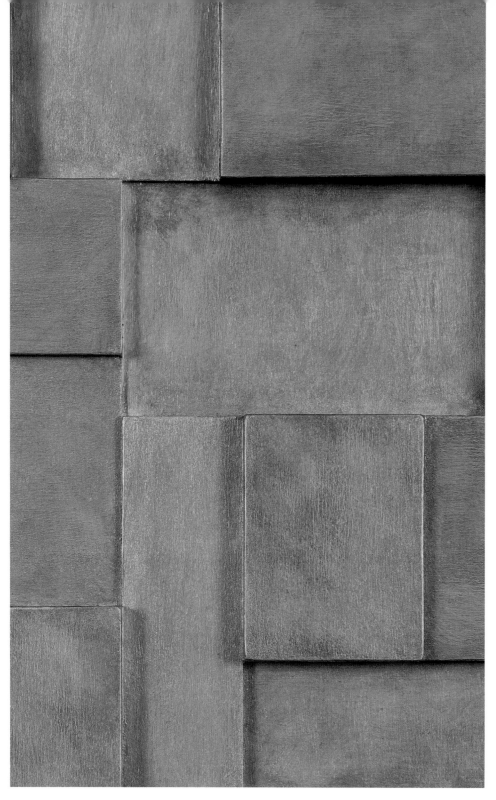

Ena G. Heller

FOREWORD

Tobi Kahn's sacred spaces (i.e. those specific projects that involve works of art within a particular ritual or meditative space) were a logical next step in his artistic journey. After all, his entire oeuvre speaks to notions of space and sacredness, and invites one into a reflective place—to the point that even an installation of his paintings in a museum was described, very aptly, as a place that "looks and feels like a chapel, or at least somewhere you might associate with the veneration of Gods" (fig. 1). [1]

This exhibition brings together a number of recent projects that deliberately mold space around art objects, or, conversely, inhabit spaces with just the right artworks. Either way, a constant in Kahn's art is that object and space are intrinsically connected, one shaping the other. And, for the next four months, all are shaping MOBIA's gallery into a new and wondrous space.

My deepest thanks go first and foremost to Tobi Kahn—for his art, for showing it to me one winter day last year and responding wholeheartedly to my suggestion of an exhibition at MOBIA. For his extraordinary talent, matched only by his generosity and enthusiasm. Once the idea of the exhibition took shape, we were lucky to engage a perfectly diverse group of thoughtful writers—and their contributions are making this book both a joy to read and a tool for teaching. I thank them from the bottom

FIG. 1 Tobi Kahn, *Sky and Water*, installation at the Neuberger Museum in 2003, Purchase, New York.

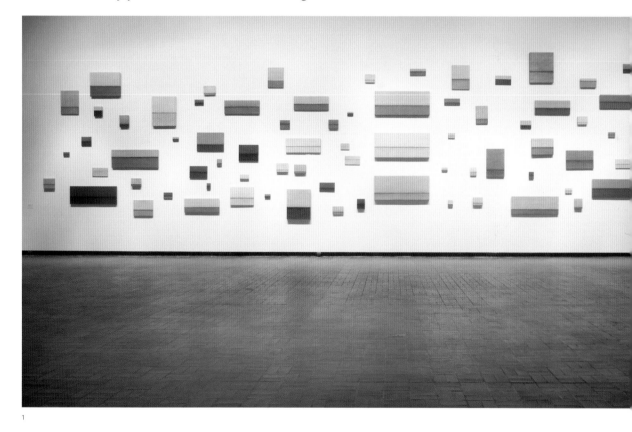

1

of my heart, as I have learned from them all: David Morgan, Klaus Ottmann, Nessa Rapoport, Daniel Sperber, and Jeff Edwards. From essays and images to a beautiful book is a long road populated with talented and dedicated people, all of whom I am grateful to: photographers Nicholas Walster and Eli Morgan; at MOBIA Ute Keyes, and at D Giles Limited, Dan Giles, Sarah McLaughlin, and Misha Anikst. At Tobi's studio, we are grateful to assistants Jeff Antonucci, Joel Haffner, Christian Kent, and Michael Serafino, and a special thank you to Sharon Florin. My research benefited from the help of MOBIA interns Stephanie Tarras and Kate Williamson. Finally, I would like to acknowledge and thank my staff at MOBIA who created a stunning installation (Paul Tabor and his curatorial staff); raised the necessary funds (Lisa Dierbeck and Megan Whitman); and ensured that the exhibition was publicized locally and nationally (Lisa Dierbeck and Debbie Bujosa).

Last but certainly not least, I am most grateful to the people and organizations who have made the publication of this catalog and the organization of the exhibition possible. They are Howard and Roberta Ahmanson, the New York City Department of Cultural Affairs, Targum Shlishi, and Harold and Estelle N. Tanner. All of them, as well as our long-time and most generous partner, American Bible Society, have made it possible for MOBIA to present outstanding exhibitions such as Tobi Kahn: Sacred Spaces for the 21st Century.

On a personal level, this exhibition has a special place in my heart twice over: it allowed me to do curatorial work once again (something I have sorely missed since I put on a director's hat), and it combined my new love for Tobi's art with my older passion and field of study, architecture and sacred space. The dialogue across centuries, modes of expressions and religions is fascinating and opens up entirely new avenues of research. I very much hope that this catalog and exhibition will do the same for their readers and visitors.

1 Benjamin Genocchio, *New York Times*, August 3, 2003, in a review of the Kahn exhibition Sky and Water Paintings at the Neuberger Museum in Purchase, NY.

Tobi Kahn

**THE MEANING
OF BEAUTY**

To create art is natural, an act in the image of the Creator, whose materials are light and darkness, generative and reflecting luminosities, and their attendant color and shadow. Art begins in the capacity to see, a mode of knowing the world and its Maker that is indispensable to the religious and cultural expression of a people.

The sacred spaces and their constituent works in this exhibition have been made for celebration and remembrance in loving community, for the marking of boundaries between holy and daily time, for the beginning of life and its end. They embody a passion for seeing. The Torah, from which our expanding tradition of text and interpretation descends, is replete with the word *re'eh*, with the glory of sight as a unique medium for exalting the Creator. Extended passages are devoted to the visual elements of the portable Sanctuary in the desert—to crimson, silver and gold, and the Jewish color *t'khelet*, to bells and pomegranates. The lush portrayal of the Tabernacle's exquisite detail, in a text that privileges brevity, teaches us how inextricable beauty is from holiness.

The centrality of beauty to holiness is not only authentic but essential to Jewish tradition. All those whose civilization bears a relationship to the Hebrew Bible share this bequest, but the making of art offers the provenance and vocabulary to exemplify it.

In the Jewish way, the divine presence is abstract, incorporeal, without beginning or end. How, then, can God be made manifest in the material world? The infinite and mortal can meet in spaces designated as liminal, dwelling places that invite our spirit, made in the Image, to encounter the ineffable God in both splendor and intimacy. The media for the engagement between transcendence and immanence are the same as those with which the world itself was created: Light, horizon, breath, pattern, the holiness of distinctions.

For me, the life of the spirit is integrally bound to the beauty of the world. Rather than being forbidden, beauty in praise of the Creator is given an honored place. The name of the Tabernacle's chief artist, Betzalel, means "in the shadow of God," for his work is understood to be divinely inspired.

Judaism is not an exclusively textual tradition, nor is the making of art prohibited because of the Second Commandment's injunction against the worship of graven images. The commandments by which Jews express their awe and love of God are *performed*; their fulfillment is often tactile. When the soul of the Sabbath departs, we breathe in the fragrance of cinnamon, of cloves. On the festival of Succot, we shake the frond of a palm tree and scent our uttered blessing with the unique perfume of the *etrog*, citron. Intrinsic to every commandment is the prospect of *hiddur mitzvah*, of amplifying the commandment's sacredness with beauty.

By the time I was six, I knew I would be an artist. Born into a Jewish life saturated with both richness and tragedy, I could not in those early years distinguish between

my vision and my Judaism. For hours, I stood at the window of my room in Washington Heights, riveted by the passing world. At my grandfather's side in the Breuer Synagogue, I was transfixed by the living green of Shavuot leaves and the pattern cast by their shadow, mesmerized by the transformation of the room into a pure white space for Yom Kippur. I thought all Jews lived in the same visual enchantment.

My parents and grandparents, refugees from Germany, honored my making art. They took my sister and me to museums, concerts, and walks in all seasons in Fort Tryon Park. My sister was named for our murdered aunt and I for our uncle, a medical student and artist who, in 1933, was one of the first three Jews killed by the Nazis. The knowledge that European Jewry was annihilated continues to shape my being.

As an artist I am obsessed by memory and its imperatives. The tribute that the dead ask of us is not only to mourn their irreplaceable existence, but to live with joy and fruitfulness. I am always aware of time's passing, of the possibility of loss, an abrupt reversal of safety. In the face of the world's instability, I want to reveal not the evident reality but its essence, its inherent vitality.

Holiness in use: The life of a community within the sacred space of a synagogue encompasses ardor and despair, turbulence and tranquility, sorrow and elation. When a community gathers, its members celebrate and grieve, rejoice in the birth of a child, a new presence, and lament the death of a beloved, newly absent.

Abstraction in imagery and form summons that most Jewish mode: interpretation. The paintings created for this sacred space are an invitation—to discover the grandeur of the world we were given, to contemplate the beginning, its first shapes and forms, to taste a return to the paradise of creation in a world that only our deeds can redeem. These works suggest the continual flowering of life, radiance and darkening, elemental particles of being, earthbound and celestial vantage points.

In living relationship to a Creator, awe and intimacy are in nourishing exchange. Throughout our lives, the microscopic corresponds to the cosmic. We praise and protect the natural world while acting to repair the brokenness—in ourselves and in the global community.

These paintings and ceremonial objects are not static; they are in communion with those who sit in their midst, awakening new and renewed ways of seeing, deepening ways of doing, and revealing beauty in light dazzling and evanescent. In this sacred space, we are porous to each other and to God.

The work created for the memorial chapel recognizes the severance from humankind of those in grief, even as they most require the solace of community. It reflects our longing, faced with the irrevocability of death, to resume our place in an infinite, benign universe composed only of the most enduring elements—the vast sky, the healing bestowed by light, the gold desert in which we were forged as a chosen

community. The painting, wall sculpture, and memorial light are designed to offer this stark consolation: Anguish can be contained in a larger, embracing world.

In the beginning, chaos became luminous, newborn. The chairs for the naming of a daughter are new ritual architecture; Jewish life does not yet have a communal, time-hallowed tradition for the covenantal naming of a daughter. These four chairs— on which mothers, grandmothers, and other wise women who transmit the power of the tradition are seated before the welcoming community—invoke the vision of Sarah, Rebecca, Rachel, and Leah, ancestral women seers, granted the discernment to choose which of their children would be blessed as leaders. Art confers on newest life the hallmark characteristics of the biblical mothers: the laughter, strength, tenderness, and fertility we seek to bequeath to our daughters.

Jews are commanded in the Torah to count the forty-nine days of the *omer* between the second day of Passover, commemorating the exodus from subjugation, to the first day of Shavuot, when the Torah was given and the Jewish people formally constituted. I was born in the middle of the *omer*, the seven-week period between the season of our liberation and the festival that celebrates the giving and receiving of the Torah at Sinai. Traditionally, Jews count each of the forty-nine days by reciting a *brakhah*, blessing, and then naming the day's number and its place within the week. In Jewish mysticism, each day and week is linked to a unique attribute of the Creator.

The counting of the *omer* represents to me the relationship between a person and his or her community. Each day is distinct, but the sequence of days and weeks is set in a larger framework. Beginning with one, we become an ordered multitude—accruing the dimensions of peoplehood in our journey from slavery to redemption.

For decades, I thought about how to embody this paradox in a work of art. The *omer* counter that resulted consists of forty-nine sculpted forms in a grid; each one can be set in its place in only a single way. By a daily act, the viewer becomes a participant in the changing work, a celebration of measured time. One by one, the gold-lined spaces of our inner lives are inhabited, each miniature structure refracting the other's light until the work is complete—and we have counted our way once more to revelation.

.

These works of sacred space and ceremony are not a rupture from the past; they express the past's living possibilities in the idiom of abstraction. They make visible a preoccupation with art and holiness, a quest to distill what we remember into essential images, archetypes that allow the past to be transformed by imagination into a capacious future, a resonant sanctuary in a still struggling world.

Ena Giurescu Heller

THE ART OF ENGAGEMENT: SACRED SPACES PAST AND PRESENT

My first serious involvement with sacred spaces took place about fifteen years ago, when I was studying the family chapels of Santa Maria Novella in Florence for my dissertation. The Strozzi Chapel off the west transept is one of the best-preserved in the church: the mid-fourteenth-century architecture, frescoes and stained glass window are intact, and the original altarpiece is *in situ* (fig. 2). I spent many hours in the church studying the details of this particular space, thinking about the connection between architecture and pictorial decoration on the one hand, function and symbolism on the other.[1] How did the architecture and decorative program of the chapel serve its primary ritual function as funerary space, and what pinpointed to its secondary and less advertised, yet equally evident, function as symbol of the social status the owner families enjoyed? How did people in the fourteenth century, the Strozzi as patrons and the others privileged enough to gain access to the chapel, experience it? And how did their experience differ from ours? These questions brought me to the larger one I pondered then, and am exploring in a very different context here today: what makes a space sacred, and for whom?

The chapel in Santa Maria Novella—or any other space (or building), for that matter, from Jewish and Hindu temple, to church and mosque, to an arbitrarily chosen space—is not inherently "sacred," at least not for everybody.[2] What makes a space or building sacred is participation in, and adherence to, an accepted ritual by a certain community.[3] This was as true at the time the chapels of Santa Maria Novella were built as it is today. One day as I was taking notes in the Strozzi Chapel, trying to decipher the intricate iconography of the frescoes inspired by Dante's Divine Comedy, a woman came up to the chapel quietly, kneeled

FIG. 2 Strozzi Chapel, Santa Maria Novella, Florence. (Photo by Vlad Bolder)

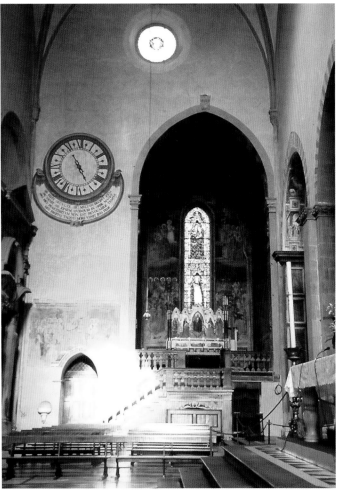

2

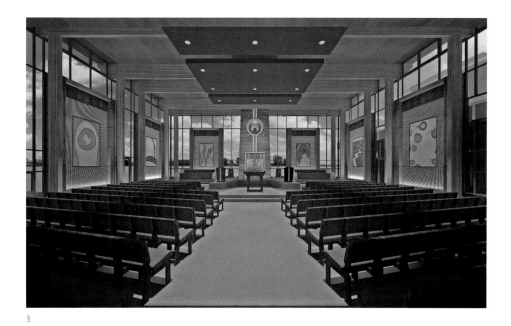

3

in front of the altar, and began to pray. I felt awkward, as if I were intruding on a personal experience (its being held in a public space notwithstanding), and as I went down the stairs to continue my writing at a slight distance, I thought of how differently that woman and I perceived the space. The same space (a richly decorated medieval chapel in a Florentine church) and time (a beautiful fall afternoon, colorful light streaming into the church through the stained-glass windows)—occasioned two entirely different experiences. My object of study, the building I admired as work of architecture and *exemplum* of artistic and religious history, was her sacred space, conducive to prayer and meditation. What was missing in my experience of the Strozzi Chapel was my being, to borrow John Shearman's apt terminology, an "engaged spectator" (at least on the spiritual level).[4]

Fast forward almost seven hundred years, to the ensemble created by Tobi Kahn for Congregation Emanu-El B'ne Jeshurun in Milwaukee, Wisconsin (fig. 3). Kahn clothed the built environment of the sanctuary—a rectangular room with a flat ceiling, walls punctuated by large expanses of window, including a clearstory level all around—with art and ritual objects. I use the term "clothed" as opposed to "embellished" because Kahn's interior art is more than just beautiful objects: it is an ensemble (as functionally and symbolically cohesive as the fourteenth-century chapels of Florence) which exalts the ritual function of the space, and makes it, for those participating in the ritual, a sacred space. The dialogue across centuries is less strained than it may seem at first, since Kahn is an artist who takes history very seriously—he knows it and welcomes its teachings. That is probably why his art finds its place effortlessly in the history of sacred, ritual and meditative spaces. Indeed, Kahn's spaces continue an honored

16

tradition even as they add a thoroughly modern, and distinctly personal, new chapter.

There is a cohesiveness in the decorative program of the chapels of Santa Maria Novella that I have always likened to an orchestra where all instruments work together to create one sound, one message. The frescoes relate to the stained-glass window, either telling different parts of the same story or complementary ones; the altarpiece highlights the patron saint of the space, or perhaps exalts its funerary function; the liturgical objects placed on the altar illustrate the ritual taking place there at different times. Together, they celebrate the patronage (both divine and human) of the space and the ritual functions performed in it. Architecture, decoration and ritual come together in a unitary scheme that at the time was considered to be the "honorable" decoration of these chapels, a fitting setting for ritual; today, it is the beauty of this ensemble that still astonishes their visitors (fig. 2).[5]

Tobi Kahn's sacred spaces resonate with the same orchestra-like quality: they are as much enclosed or delineated by the artworks as they are created by the ritual which they help perform. Kahn first experimented with the relationship between object and the space around it (or inside it) in his devotional and liturgical objects most often referred to as shrines (fig. 4).[6] Yet more than once he called them sacred spaces, meaning to evoke "ancient sacred spaces and figures that seem to have always been there."[7] The play of opposites—enclosure/void; presence/absence—endows them with a powerful tension. From there, working on a larger scale was the logical next step: in recent years, Kahn has moved into constructing actual sacred spaces. In them, the enclosure (both architectural and decorative) is as important as the space within it, the objects which

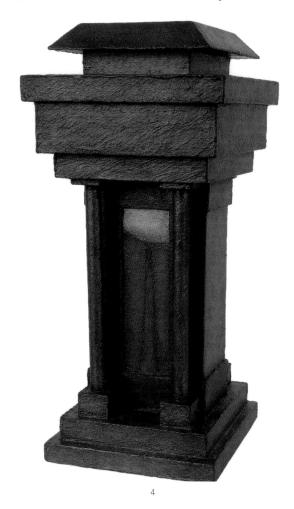

FIG. 4 Tobi Kahn, *Aruga I*, 1987. Spice box, acrylic on wood, 13½ × 6 × 6¾ in.

4

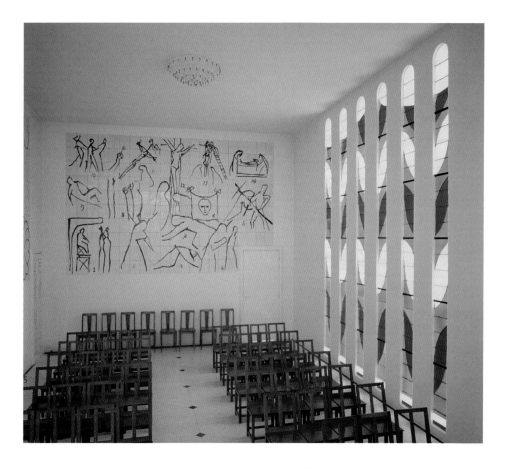

populate it, and the people who perform the ritual(s) which give it meaning. Kahn's sacred spaces combine several of his interests—painting, sculpture, ceremonial objects, furniture, sacred space, religion, and, perhaps most importantly, illustrate his deep belief that art can transform, heal, and even redeem. The artist once said, "I used to love making very small meditative spaces of small, sculpted objects that people could hold in their hands. But now I want to hold you, the viewer, visually and conceptually within a created space."[8] From the point of view of their beholders, these environments expand the notion of spiritual engagement with the work: instead of handling objects we move around them, we define and delineate a ritual, whether personal or sacred.

Kahn's predecessors in the twentieth century, those artists who worked in churches and synagogues, public and personal meditative spaces, have articulated a modern language for artwork that serves the liturgy, dialogues with religious history, expresses the spiritual—and defines "modern" sacred spaces. Matisse's Dominican Chapel of the Rosary at Vence (1951) and Rothko's chapel at Houston (1971) are two of the exemplars that most readily come to mind. Matisse translated the ritual and symbolic needs of

the Dominicans into a modern idiom, using sparse line, pure color and abstraction to express the mystical (fig. 5). An avowed non-believer, the painter absorbed the theology and the iconographic history of the Dominican order and translated it into a modern sensibility: his chapel works for those who use it as a place for religious ritual, and it works equally well for those of us in search of a modernist ensemble.[9] While Matisse's painting is a delicate enhancement of the architecture, in Rothko's chapel in Houston the space is largely shaped by the paintings (fig. 6). In a letter read at the dedication of the chapel (which Rothko could not attend due to health problems) the artist wrote that he considers this his masterpiece, and a "result of his whole active life."[10] The power of this religious environment lies in the relationship between paintings and architecture, the dialogue among the paintings and between them and the space they at once delineate and populate. To say that the space is conducive to religious experience is an understatement; its genius is that it accommodates (indeed, invites) any number of such experiences.

Matisse's and Rothko's spaces belong to the same (rather small) family of projects that embody an "authentically modern religious art."[11] Not many contemporary artists have followed that path; only a courageous few have ventured to counter the prevailing view that art and the sacred are permanently divorced. A recent exception is Anthony Caro's work in the choir of the church of St. Jean Baptiste at Bourbourg (Pas-de-Calais, France), dedicated in October of 2008.[12] Another exception is Tobi Kahn's ensemble for Emanu-El B'ne Jeshurun in Milwaukee, to be dedicated this year (2009).

Common to all these successfully modern sacred spaces is their being rooted in history. Matisse is known to have studied Grünewald and Dürer, as well as Byzantine and Romanesque images, for his paintings at Vence.[13] Rothko placed his paintings, pressed between the doorways of the chapel (in turn placed close to the edges of the walls) in a way reminiscent of Michelangelo's New Sacristy in Florence.[14] Kahn used the outline and proportions of the domed Hurva synagogue in Jerusalem in the architecture of his tzedakah box for Milwaukee (cat. no. 15), thus symbolically signifying the holy city into this ritual object.[15] Similarly, he used a topography suggestive of the rooftops of Jerusalem, with their diverse outlines, in the individual shapes composing the Omer counter (SAPHYR II, cat. no. 24). Both these examples illustrate Kahn's penchant for the suggestive rather than the literal: while referencing important symbolic prototypes, he always leaves space for other interpretations, inviting viewers to weave their own personal narrative for a certain work. It has been suggested that the importance of multiple readings may come from Kahn's familiarity with searching for as many interpretations as possible in a given text, which he would have practiced in the years of study at Yeshivot, both in the U.S. and in Israel.[16] But I believe it is equally rooted in Kahn's deep belief in the polyvalent nature of any work of art, and his genuine curiosity about the interaction

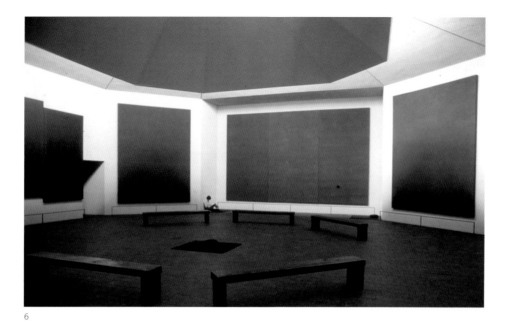

6

FIG. 6 Mark Rothko,
Rothko Chapel
(interior view),
Houston, Texas
(Photo Credit:
Nicolas Sapieha /
Art Resource, NY).
By permission
of Artist Rights
Society.

it engenders with different viewers and in different contexts. And because Kahn's narratives tend to be suggestive and not literal, they consciously invite multiple readings. He has once said that his images are always rooted in recognizable things, but not so specific as to lead to foregone conclusions.[17] Indeed, literalness can strip art of the magic of discovery, and one of the remarkable things about Kahn's art is that constant magic, the journey it invites us on, the discovery we make on the way.

In a recent interview Kahn said that what interests him the most is the dialogue created by a work of art. He's delighted when people see different things, different symbols, and different stories in his art: his preferred viewer is an active participant.[18] Kahn's "active participant" is Shearman's "engaged spectator:" a spectator who takes an active role dialoguing with the work rather than passively observing it (the casual or disengaged spectator). According to Shearman, a beholder experiences engagement in three consecutive stages: awareness, involvement, and complicity.[19] In the case of the Strozzi Chapel, a casual spectator spends a few minutes looking around (what a beautiful chapel, adorned with beautiful frescoes and window and altarpiece), and she is out the door. The involved spectator lingers and thinks about the relationships between these different art forms, and about the symbolism of the imagery, and the function of the chapel when it was built. Finally, the fully engaged spectator complicitly alters the meaning of the work by adding her own perspective and experience. I would make a further distinction between altering or contributing to the meaning of the work in a ritual sense (by experiencing one's private religious experience, as the woman praying in the Strozzi Chapel) or in an intellectual sense (as I was hoping to do that same day, by adding to the scholarly interpretation of the

decorative program of the chapel). Either way, it is this "active participant" who delights an artist like Tobi Kahn, and gets the most out of his art.

SAPHYR II is a splendid example. First, it is a liturgical piece that is Kahn's invention, without any artistic precedents in Jewish ritual—so from the beginning it engages us with Kahn's creative adaptation of ritual to modern and personal needs. Second, as a ritual piece, it needs to be viewed (i.e. interacted with) over the course of time: specifically the 49 days between Passover and Shavuot. Every day one of the differently shaped pieces is put in its place. It follows that every day the sculpture looks different, and that each piece enhances the others—until the end, when the sculpture is complete and displays forty-nine different shapes in dialogue with one another (fig. 7). One can also choose to do the counting in reverse, starting with all forty-nine pieces in place and taking one out every day—creating yet another spatial and ritual experience. The Omer counter embodies the principle of changing experience (ritual and/or spiritual, aesthetic, and more generally participatory) to its fullest. Yet the same is true of other works whose appearance does not change. What changes, though, is the way we experience the ritual meaning. In general, meaning is shaped by the relationship between the sculpture (or another art object), the space around it, and the beholder: none of the three components functions without the other two. Sacred space, in this definition, is not only enclosed by architecture, it is also shaped by objects and people; to quote David Summers, it is specified by "the shared physical presence of paintings, buildings, observer."[20] It is precisely the concept of sharing that is most important to Kahn. The people create the ritual, which in turn defines the sacredness of the space. Kahn recently told me that for him ritual or sacred art needs to function

FIG. 7 Tobi Kahn, *SAPHYR II*, Omer counter, 2004. Acrylic on wood, 72⅝ × 58⅝ × 24¹¹⁄₁₆ in.

7

on three distinct levels: visual, functional, and *halakhic*. Here again he conducts an interesting dialogue with tradition: one is reminded of Rabbi Jair Hayyim Bacharach, who in the seventeenth century wrote that the decoration of a synagogue needs to obey decorum (be "fit to honor the synagogue"), preferably use expensive materials, and—importantly—meet the community's aesthetic standards.[21]

Indeed, Kahn's art (even when inventing new, and thoroughly modern, rituals) is deeply rooted in history. His works derive from an informed interpretation of the Bible, Jewish history and Jewish ritual, even as they conduct a dialogue with art, history and ritual more globally. The Shalom Bat chairs (cat. no. 25), another Kahn invention, illustrate these concepts well. The chairs were one of eleven projects undertaken by Kahn after the death of his mother; according to the artist, they were conceived as visual *kaddish*.[22] They connect with the ritual ceremony of welcoming and naming a baby girl into a Jewish family, itself a modern practice mirroring those traditionally held for boys.[23] The four chairs symbolize the biblical matriarchs Sarah, Rebecca, Leah, and Rachel—and through them the long line of Jewish women, forebears of any newborn girl. The surface of the chairs is built similarly to Kahn's paintings, with layer upon layer of paint, sanded to acquire texture and built up painstakingly, until it acquires a distinct three-dimensionality and a rich surface. The strong, vibrant colors indicate the celebratory event they commemorate. The chairs have very tall backs, which make them imposing, rather like thrones. One thinks yet again of historical precedents, for instance the bishops' *cathedrae* in Christian churches, or the thrones upon which the deceased were represented on ancient funerary *stelae*: the Shalom Bat chairs combine functionality with symbolism that connects with the sacred text and rituals deriving from it.[24] In recent times, empty chairs with tall, straight backs composed the memorial for the Oklahoma City National Memorial (Hans and Torrey Butzer and Sven Berg of Butzer Design Partnership, 1999), symbolizing the lives taken by the terrorist bombing of 1995 (fig. 8). What all these apparently disparate ritual and memorial objects, including Kahn's, have in common is the fact that they embody presence and absence at the same time. A bishop's *cathedra*, while serving as the place of honor for the bishop in a church, symbolizes Christ's presence through his temporal (and temporary) appointee in the hierarchy of the church. Ultimately, that throne will receive Christ physically at his Second Coming. Kahn's Shalom Bat chairs are used by mothers and grandmothers holding their daughters and granddaughters during the ceremony of welcoming them to the world but also symbolize the matriarchs of the Hebrew Bible—as ancestors of all baby girls and role models for all Jewish women. One thinks, in both cases, concomitantly of the present occupants of these chairs, and of the eternal symbol they stand for. Again, it is the interaction with the object—the relationship of engagement—that makes the meaning of the object fully reveal itself and become significant to us.

As participants in the ritual which reveals their meaning, the Shalom Bat chairs (and their occupants) mold the space around them. The space, yet again, is part of the work's ritual significance, while the work itself—the individual chair—acts as the center which, according to the classic work by the historian of religions Mircea Eliade, focuses the space and at the same time marks it as sacred, by acquiring "orientation in the chaos of homogeneity."[25] This sacred center, as defined by Eliade, grounds us and helps us direct our energies into a religious experience. Tobi Kahn's Shalom Bat chairs similarly invite us to sit, and by doing so, to devote ourselves fully to the ceremony for which they were invented.

Indeed, Tobi Kahn's sacred spaces and the objects that create them invite our participation in a way that is at the very least reflective, if not fully spiritual. Yet each of us can define the spiritual nature of the experience—the artist does not guide us in a single direction. The artworks from Congregation Emanu-El B'ne Jeshurun, to be sure, are read differently in the space of our museum than in the sanctuary they were created for. The experience they engender is different yet equally powerful— and their very ability to mold the space around them and the perception of the active participant, differently if in different contexts, is the true indication of their transformative power. After completing his work at Vence, Matisse mentioned in an interview that "all art worthy of the name is religious."[26] I agree, and I believe so does Tobi Kahn. As for this particular exhibition of his art, I would invert that statement and say that sometimes, even in the twenty-first century, we are the lucky recipients (and engaged spectators) of religious art that is worthy of the name "art."

FIG. 8 168 chairs marking the lives lost in the Oklahoma City bombing of 1995 (by 2 military veterans against federal government), Oklahoma City, Oklahoma. Credit: The Art Archive / Global Book Publishing

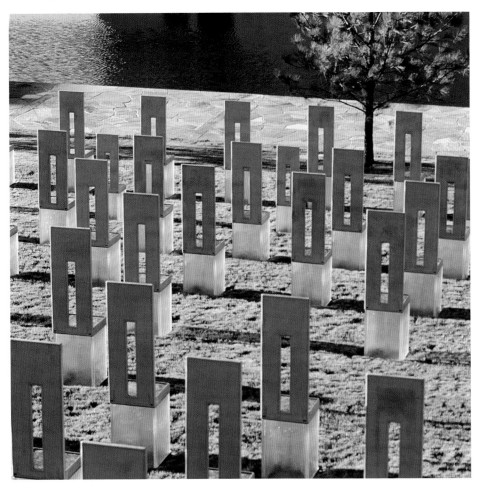

8

1　See Ena Giurescu, *Trecento Family Chapels in Santa Maria Novella and Santa Croce: Architecture, Patronage, and Competition* (Ann Arbor, MI: University Microfilms, 1997).

2　Theodore L. Prescott, in "Spare Holy Spaces," *IMAGE* 49 (2006): 17, makes the point that for many, the physical requirements for worship are minimal; the website *Sacred Space* (http://sacredspace.ie/) invites people to make a 'sacred space' in their day no matter where they are (at their desks, at home, in their cars, etc.) and pray for 10 minutes.

3　See the excellent collection of essays in Louis P. Nelson, *American Sanctuary. Understanding Sacred Spaces* (Bloomington and Indianapolis: Indiana University Press, 2006), which analyzes sacred spaces in different American religions.

4　John Shearman, *Only Connect... Art and the Spectator in the Italian Renaissance*. The A. W. Mellon Lectures in the Fine Arts, 1988, Bollingen Series XXXV/37 (Washington, DC, and Princeton, NJ: The National Gallery of Art & Princeton University Press, 1992), esp. 10–58.

5　Giurescu, *Trecento Family Chapels*, 212–26.

6　Emily D. Bilski et al, *Objects of the Spirit. Ritual and the Art of Tobi Kahn* (New York and Manchester: Avoda Institute, Ltd. and Hudson Hills Press, 2004).

7　Matthew Baigell, *American Artists, Jewish Images* (Syracuse, NY: Syracuse University Press, 2006), 194.

8　Interview with the artist in *Sh'ma* (a publication of *Jewish Family and Life*) 35/618 (February 2005), 7.

9　On Matisse's collaboration with Father Couturier and other Dominican advisors see, among others, Gabrielle Langdon, "A Spiritual Place: Matisse's Chapel of the Dominicans at Vence," *Zeitschrift für Kunstgeschichte* 51/9 (1988), 542–73.

10　Dominique de Menil, "The Rothko Chapel," *Art Journal* 30/3 (Spring 1971), 249.

11　David Summers, *Real Spaces. World Art History and the Rise of Western Modernism* (London: Phaidon, 2003), 643.

12　See Laura Gascoigne, "Rising from the ashes in the hands of Anthony Caro," *Art Newspaper* 196 (November 2008), 42; Margaret Garlake, "Anthony Caro's *Chapel of Light*," *Art and Christianity* 56 (Winter 2008), 12–13.

13　P. Schneider, *Matisse*, trans. Michael Taylor and Bridget Strevens Romer (New York: Rizzoli, 1984), 688–89.

14　Summers, *Real Spaces*, 646.

15　The Hurva synagogue (built in stages between the eighteenth and nineteenth centuries in a neo-Byzantine style) was once a focal point of spiritual life in Jerusalem; it was destroyed in the war of 1948 and finally rebuilt in recent years. See the article in the *Jerusalem Post* of March 28, 2008 at http://www.jpost.com/servlet/Satellite?cid=1206632351868&pagename= JPost%2FJP Article%2FShowFull.

16　Baigell, *American Artists*, 192.

17　Theodore Prescott, "Tobi Kahn: A Profile," *IMAGE* 33 (Winter 2001–02), 32.

18　I would like to thank Tobi for sharing with me a video still in progress, from which I quote here.

19　Shearman, *Only Connect*, 17.

20　Summers, *Real Spaces*, 647.

21　Quoted in Vivian B. Mann, "Spirituality and Jewish Ceremonial Art," *Artibus et Historiae* 24/48 (2003), 181.

22　The number mirrors the eleven months following a parent's death during which observant Jews say the mourners' *kaddish*. For a very brief overview of this custom, see Marc-Alain Ouaknin, *Symbols of Judaism* (Paris: Editions Assouline, 1995), 96.

23　Alfred J. Kolatch, *A Handbook for the Jewish Home* (Middle Village, NY: Jonathan David Publishers, Inc, 2005), 4.

24　Terrence E. Dempsey, S.J., "Shaping the Sacred in Contemporary Art," in Bilski et al, *Objects of the Spirit*, 63–64.

25　Mircea Eliade, *The Sacred and the Profane. The Nature of Religion*, trans. Willard R. Trask (New York: Harcourt, Inc, 1987), esp. 23–24.

26　Quoted by Langdon, *A Spiritual Place*, 559.

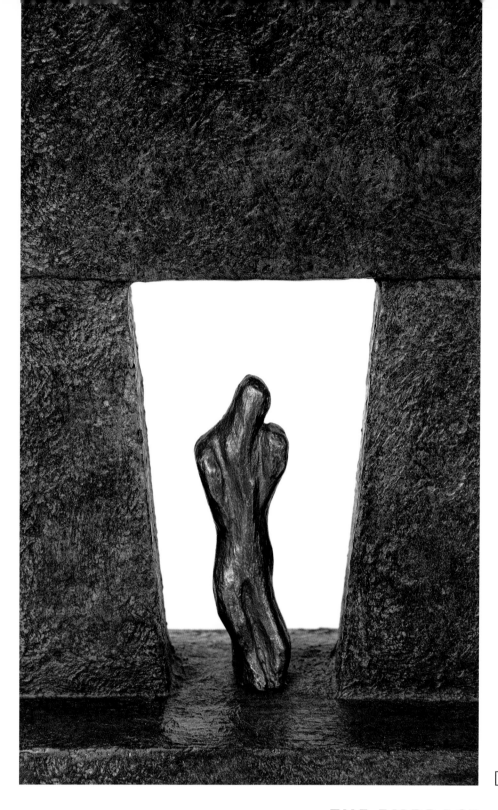

David Morgan

THE EMBRACE
OF THE WORLD:
ART AND THE MATTER
OF WORSHIP

The material evocation of the sacred began long before the existence of "art" and "religion." Those are inventions of the modern world, where art is not the same as artisanship and religion is communal ritual deliberately separated from the secular world whose public norms are defined by politics, business, and science. In the modern world, religion has become a private matter and vanguard art has nothing to do with religious communities. There is good reason for these distinctions. On the one hand, art that is controlled by institutions lacks a self-determined voice. And on the other, if democracy is to survive as genuinely democratic, religion must remain both free and limited. The First Amendment to the American Constitution gets this right, even if many latter-day (mis)interpreters of it do not. Where religion goes public, such as the ceremonies of civil religion, it must avoid sectarian specificities if church and state are to be kept at a healthy distance from one another.

The point to be made here is that modernity introduced the key element of privatization into the definition of religion and art, thereby effectively conjuring them into existence. Both used to be yoked to the dominant province of public and coercive institutions—the state and the church. The integration of ritual, divination, theology, temples, monuments, and frescoes into the operations of the state was so complete that it is no exaggeration to say that art and religion *as such* did not exist. What prevailed was formal ceremony and propaganda, the material practice of authority, the invocation of the divine, the exercise of power, sundry theurgic rites of alignment and soothsaying—all unfolding as part of the dramaturgy of imperial, royal, and ecclesiastical mysteries. Artists were artisans, practitioners of their craft who were hired out to provide services to the sacred apparatus of the state. Believers participated in their communities as Jews, Christians, or Muslims, for example, in a way that made politics and belief virtually indistinguishable. Conversions for the sake of employment and advancement in life were much more common than today, when people convert for private, that is "personal," rather than public reasons. In one important sense, modern religion is the result of cordoning off belief from the machinery of governance. This privatization both protects it from state incursion, and constrains its exercise in the public square. Fundamentalists resent this, while most of the rest of us do not.

Beauty, as a category of judgment, arose as the province of the faculty of taste in the eighteenth century. Before then, beautiful things were characterized as magnificent, sumptuous, precious, fair, comely. To be sure, artisans made things that we today call "beautiful," but by that word we mean something different when we speak of art. We tend to think of such beauty in terms of rarity, as unique, as timeless, as something we perceive in and of itself. The mode of display in museums accommodates that expectation: perched atop a pedestal or hung on a neutral wall, physically separate from other objects, ideally lit from above, framed in a way

to make it stand off by itself, the object is enthroned for rapt contemplation, for aesthetic delectation. But that's not how most "beautiful" objects existed before the modern world. They were not beautiful in and of themselves, but as part of an entire ensemble, to which they contributed their portion of splendor, rare materials, and craft. The objects were not about themselves, but about what they did, about the ritual of power, mystery, or metamorphosis, about the great mythic narratives they helped perform.

In his way, this is the divide that Tobi Kahn surveys and seeks to span in his splendid assembly of objects for Congregation Emanu-El B'ne Jeshurun (fig. 3) and the Shaykin Family Foundation (cat. no. 25). According to the *Oxford English Dictionary*, the word 'liturgy' derives from an ancient Greek term (*leitourgia*) that meant public service, service of the Gods, or public worship. As "public," the religious service was not a setting for art, but for the crafts of music-maker, cantor, architect, and decorator. *Service* meant submission to a purpose larger than the object or its maker. Liturgy was service to the divine unfolding in time and space in media and practices that were not incidental to the experience of the sacred, but the very matrix of it. The word still carries that idea. Although it is incessantly updated and renovated, liturgy is not understood to be the creation of an individual. It arises from tradition and hands on the way of the fathers and mothers. In an important sense, the observant do not make liturgy, but ob-*serve* it. In doing so, they join the footsteps of the ancestors, take part in a community and communion that is ancient, ultimately descending from the divine itself to whom the service is dedicated.

Does Tobi Kahn make art or ritual objects? He pushes the line and intends to do so. His Shalom Bat chairs (see cat. no. 25) and his Omer counter (cat. no. 24) are inventions of his own. There is no traditional liturgical stipulation for these objects, though Omer calendars are not uncommon. Yet both his chairs and sculptural counter respond organically to living practice. To sit in the chairs of the mothers and name the daughters places old and young in one company, enthroning name in body with a holiness that began as the first parent's naming of all creation. What is in a name? The whole embrace of the world. In the Omer counter, Kahn

FIG. 9 Bench displaying various religious texts, entrance area of the Rothko Chapel, Houston, Texas, 2007. (Photo by David Morgan)

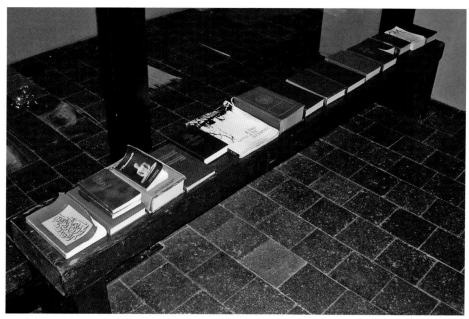

9

28

materializes an ancient practice of counting the forty-nine days between Passover and Shavuot, the celebration of Moses' receiving the Torah on Mount Sinai. The Omer counter bears seven times seven odd shapes, each the peculiar form of a day, the singular package of time that liturgy marks out in its countervailing march across the span of seven weeks. Each day proceeds from the offering on one measure of barley (*omer*), traditionally presented in the Temple as thanks for the harvest, but here expanded to the modern, post-agrarian world to remember an economy of human-divine relations that affirms the breadth of what may be sacrificed as gratitude to God. The task of liturgy is to make a place for the sacred in the nest of the ordinary. The Omer counter therefore gathers the days together like a brood of wrapped gifts. Kahn gives ritual time a look, a feel, a texture, and a presence that is new, but ancient for being novel. The familiar returns with a strangeness that reintroduces it. Art confronts ritual and offers it a new chance in a world that readily forgets it.

Yet what Tobi Kahn has crafted for the synagogue of Congregation Emanu-El B'ne Jeshurun is, on the face of it, more traditional: memorial lights, candlestick holders, and painted panels. These are liturgical appointments, the tools by which worship takes shape, concretizing the sacred as a reverential service to God. Compare this space to the culminating work of Mark Rothko, the chapel in Houston (fig. 6). In the entrance area outside of Rothko's chapel sits a long bench of spiritual manuals from more than a dozen different religious traditions (fig. 9). If they like, visitors may select the one that suits them and imaginatively adapt the severe minimalism of the chapel's interior to their own devotion. Tobi Kahn has not crafted an interfaith space in this instance (although he has in others—see fig. 10), but a synagogue. And yet he is not a liturgical consultant programming worship. The objects have been fashioned by an artist and they reward the contemplation that engages us on any trip to an art museum. The painted panels float in frames (cat. nos. 1–4 and 5–9), recalling an art gallery's display of images. If the paintings here envision the attributes of God as the proper framework for worship, they are by no means illustrations of them. Each panel is titled with a cluster of letters that the artist has derived from Hebrew words, not as a mere cipher, but as a way of distancing the images from the simple task of reference. Kahn seeks to strike a delicate, but crucial balance. It is not art that the congregation worships, nor art that sees only to itself, but art that worships God with the congregants, materializing their collective act of worship. If that balance is charged with tension, if it abounds in ambivalence, that is because resolution would flatten the objects with the dull thud of symbolism.

The question of what the artist has created—art or liturgical objects—matters to those who want to understand the relationship between art and religion, art and ritual, and art and liturgy. Couched in these connections is the perennially troubled relation between tradition and innovation, between the past and the modern world. This nexus

matters to anyone who struggles to be part of a religious community. But it also matters to scholars and discerning viewers who wish to see clearly what Tobi Kahn has done.

The visual dimension of liturgy in both Jewish and Christian traditions is often heavily symbolic. Christian theologians and clergy are fond of symbols keyed closely to texts and dogmas because this manner of symbolism assists the didactic exposition of teachings and scripture. Rabbis and Jewish scholars regard symbols similarly, with the additional desire to avoid figurative imagery proscribed by the Bible. In both cases, symbols subordinate the autonomous, open-ended power of imagery to the more controlled code of discursive texts. Such symbols are understood to stand for ideas, to the conveyance of which they submit themselves like thankless beasts of burden. Once the idea is brought to mind, the symbol is quietly pastured, eclipsed by its prevailing content or meaning. Message trumps medium. Routine replaces inspiration and faith becomes a matter of correct information. This happens nowhere so readily, nor so disastrously for its effect on imagination, than in the instruction of children, who are urgently and repeatedly doused in "essential" information, what every good Jew or Christian should know. The liturgical expression of this mechanical sensibility plays out in the excessive deployment of discursive symbols, a kind of visual shorthand of dogma applied in a pedagogy of repetition and clarity. Memory is the target; imagination the victim; ambivalence the arch-enemy.

Those who suffered through years of Hebrew or Sunday school may recall the exhilaration of posing unexpected and stymieing questions to their teachers. Suddenly the conversation got interesting. Thinking—creative, imaginative thinking—erupted into the mind-numbing ceremony of instruction and real learning got a gasping start. Usually it ended as quickly. But the romance of open-ended conjecture, the heady scent of "what if?" dethroned unwitting authority and invited the student on a quest. Scripture is full of paradoxes and wisely so because they are magnets for the imagination. Their poetic aspect seizes the mind and taunts it, leading the seeker into the intricacies of the text, which means learning to celebrate its ambivalence as inherent and alluring. Some symbols can do the same by preserving an opacity, a thickness that does not go away, a depth that lures the imagination into a journey of discovery. This is what Kahn achieves in his paintings. They are not wallpaper, but rigorously, complexly worked surfaces that suggest more than they deliver. Viewers return to them for that reason, and will continue to do so. Like stories and verse, they will goad the viewer, promising what only wonder may pursue. What better way to ponder the attributes of the divine?

The secret to powerful symbols resides in their resistance to clear interpretation. When a symbol is reduced to a one-to-one relation to its meaning, it becomes as useless as the husk of a nut removed from the meat it once concealed. No less important is what this approach does to the sacred when it is understood as meaning

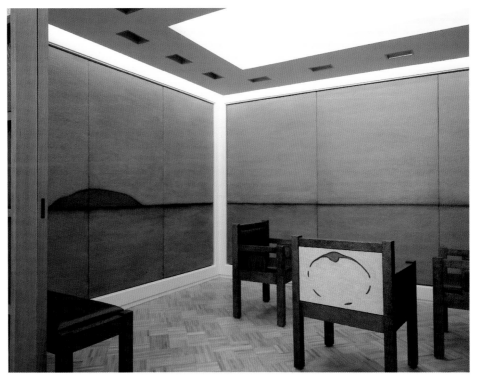

10

extracted from the indifferent shell of the symbol. When liturgy operates this way, it exchanges the mystery of the transcendent for the canned, memorized reiteration of information. The wild, insecure, unpredictable spirit is cloaked by custom, "the way we've always done it," the stale, tame, same old thing. Tobi Kahn's work is a passionate protest against this. His images and objects appeal for believers and non-believers alike to recognize that religion is not about dogma; that it is not captured by the machinery of decoding symbols.

Kahn did not conceive the eight panels limning the interior of the synagogue as discrete symbols, keyed to the discourse of historical or ritual events. The panels do not image the days of the week, the holidays of the Jewish ceremonial calendar, or the tribes of Israel. Nor is there a hidden meaning to be divined by special knowledge of the Zohar or the Talmud or any other text. His images are not about ideas. They are not *about* anything. They *are* metaphors. Participating with the architecture to create the space of liturgy, they are the look of voice and movement, a polyphony of allusions, a perimeter of visual evocations. They hint and point and dance, but refuse to declaim. They congeal, then dissolve. They coax, then skip away to hide behind their frames. What we see are fragments of something largely concealed, an apt metaphor of divine truths, of a deity known for a perplexing pattern of absence and

presence. Kahn's images vibrate between figure and ground. Their textured surfaces work with the architecture to repudiate the familiar and lethargic tendency to turn everything into the monotony of blank walls, glitzy stained glass, mosaic busy work—visual muzak. Instead, they hang on the edge of the space, restlessly defining it with boundaries that do not presume to confuse themselves with the One who cannot be contained.

Tobi Kahn has made sensuous traces of the mystery that calls the Jewish people together as a community of feeling, shaped by a history, facing a common present, hoping in the face of a looming future. The act of worship is a performance of *aesthetic* kinship, using the term as Aristotle might have meant it. God has made promises and the liturgy is Judaism's way of holding God to those promises and to the people whose life the promises sustain. Promises are alluring because they are not finished. They remain open and alive. One inhabits them. They happen in the living space of memory, in the body of a people. They are felt and heard and seen and tasted. The affective life of promise, of covenant means that worship comes already embedded in space and object and image, in the glory of stuff and matter.

I began with the modern division of ritual and craft into religion and art. Rather than pining for the past, Tobi Kahn affirms that we are the product of our time. This allows him to regard the present as the medium of revelation. Every act is an engagement of the surging present with the living past, and therefore the creation of what might come. In the form of his current work, art and liturgy come together to create a hybrid for the practice of faith, for the aesthetic healing of the troubled modern soul. This means in part that Kahn proposes in his work to address the separation of art and religion wrought by modernity. If forced to choose between the two—is he making liturgical objects or art?—he would surely side with the latter. But his work argues for overcoming an absolute split. Art brings something uneasy to religion: an impatient desire to match feeling to paint, to push boundaries and topple expectations. But the confrontation with religion is not inapt. The zeal of art answers to something deeply religious: the restless longing that fuels belief, belief that is not satisfied with itself, belief in which doubt and quest and passionate tenacity prevail. Moreover, artists like Tobi Kahn practice a wisdom that believers do well to heed—the understanding of the body's senses. In their longing for purity and spirit and the transcendence of the divine, believers are sometimes inclined to let symbol and teaching supplant the felt-life of faith. But if human bodies are an integral aspect of human consciousness and the experience of the world, missing the materiality of religion means missing lived religion altogether. Tobi Kahn's paintings and objects entice the body back to faith, working on spirit in its earthly medium of matter.

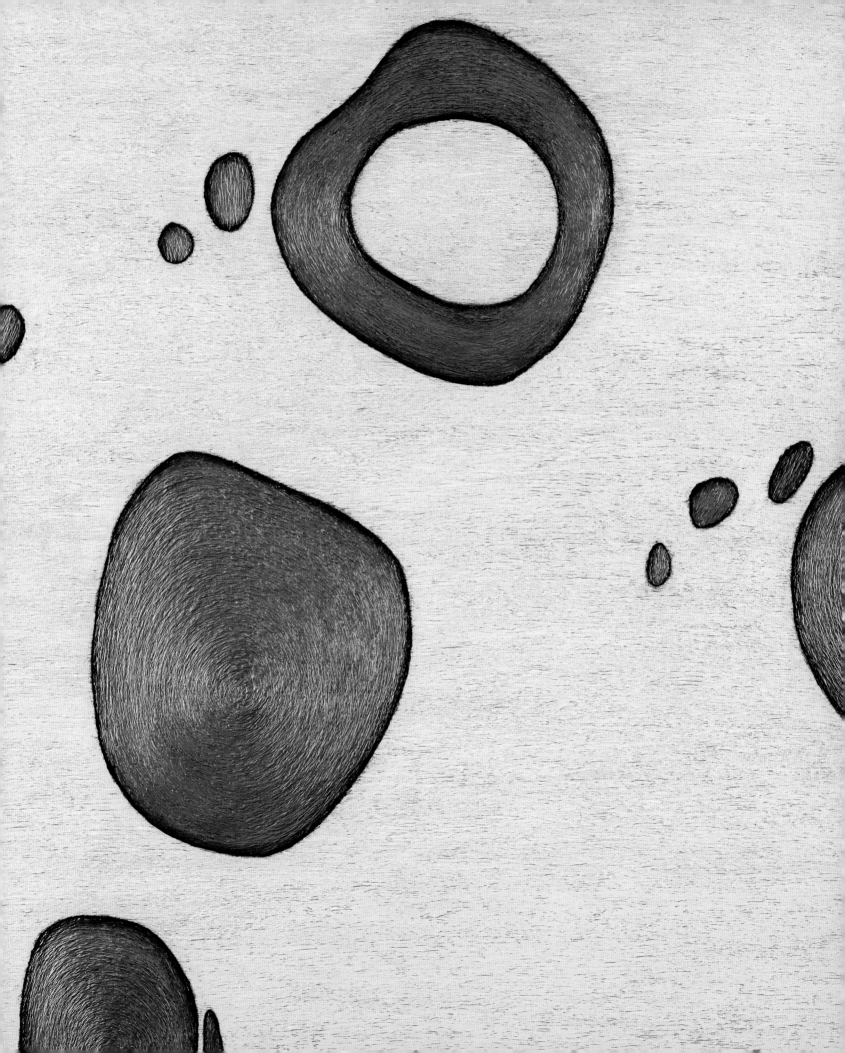

Klaus Ottmann

**THE ETHOS
OF TOBI KAHN'S
SACRED SPACES**

Ethos describes how human beings exist in the world as a community. Sacred spaces are where the spirit that presides over its activities dwells, continuously renews itself, and aspires toward holiness. Sacred spaces are not limited to churches or synagogues dedicated to religious services. Most modern ones are characterized by a certain asceticism or impoverishment, an inherent minimalism that is expressed in the glorification of "poverty" as it is bound to holiness. It is in this poverty that the aesthetic and the spiritual coincide.

In early 1965 Mark Rothko signed a contract to produce a set of murals for a Roman Catholic chapel to be built in Houston, Texas, by the de Menil family, prominent Houston art patrons. The chapel, located in the Montrose District near St. Thomas University, was dedicated on February 28, 1971, almost one year exactly after Rothko's dramatic suicide. Its interior space graced by the presence of fourteen monumental canvases, painted with a severely reduced palette of dark maroon-and-black, is one of the most important artistic commissions initiated by private citizens in the twentieth century (see fig. 6). Not since Michelangelo's New Sacristy in Florence, designed during the Renaissance, had an artist created such solemn visual unity between architecture and art. Originally conceived for Catholics, the Rothko Chapel now receives people of all faiths.

More recently, the Dwan Light Sanctuary was constructed on the campus of the Armand Hammer United World College in Montezuma, New Mexico, a two-year international high school. Designed in 1996 by the artist Charles Ross with the architect Laban Wingert, it is a place for quiet reflection (fig. 11). The sanctuary consists of a round chamber whose dimensions and sloping white-plaster walls are based on astronomical relationships and seasonal angles of the sun. Twenty-four large prisms at the apses and the roof of the Sanctuary produce changing solar spectrum events that circulate across the white plaster walls and the grey concrete floor during the day, and lunar spectrums at full moon. At night, the North Star is visible through a square aperture high up in the wall from the center of the floor. Ross's solar spectrums and Rothko's chapel murals represent the opposite sides of what the German philosopher and cultural critic Theodor W. Adorno once referred to as "negative apotheosis of color" that pushed art "to the brink of silence."[1]

The Russian art historian and Orthodox priest Pavel Florensky wrote in his little-known book on painting, *Iconostasis* (after the wall in the Orthodox church that separates the altar from the nave, the realm of the invisible from the visible):

FIG. 11 Charles Ross and Laban Wingert, Dwan Light Sanctuary, Campus of the Armand Hammer United World College, Montezuma, New Mexico, 1996.

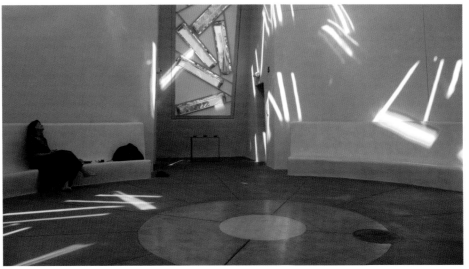

11

which falls between Passover and Shavuot. This early on instilled in him a sense of responsibility for others. *SAPHYR II*, like its smaller counterparts, can be considered as a coming to terms with the issue of slavery and redemption on a very personal level.

The work is meant as a participatory work. Every day, during the forty-nine days, a different piece is removed from the counter and preferably placed temporarily atop the sculpture (see fig. 7). In the Kabbalah, each week is associated with one of the seven lower *sefirot,* creating forty-nine daily permutations, each representing an aspect of the Divine character worthy of emulation. In *SAPHYR II,* at 72 inches high and 58 inches wide, each of the individual forty-nine cubes seems to literally represent one unique personality. All together, they form the *ethos* of a community.

Kahn began creating sacred spaces in 1993, when he was commissioned by the philanthropist Jane Blaffer Owen to design a meditative outdoor space in Indiana. *Shalev* (fig. 12) consists of a bronze figure standing inside a twelve-foot-high granite arch, with several smaller stones placed around it, and is located near Maclead Barn Abbey, a well-known spiritual retreat in New Harmony, Indiana. His most recent and ambitious commission is for Congregation Emanu-El B'ne Jeshurun in Milwaukee, for which he is creating eight six-foot-high murals, a pair of carved-wood doors, painted silver, for the Ark (which houses the Torah scroll), the Eternal Light in the shape of a pomegranate (one of seven species that Israel was blessed with, mentioned in the Torah), two wooden menorahs, a memorial light, a set of mezuzot, a tzedakah (charity) box, Shabbat candlesticks, and a Havdalah set (cat. nos. 1–10, 14–20).

According to the French phenomenologist Emmanuel Levinas, transcendence is not a modality of essence—not a question of being or not-being—but rather an ethical imperative; it is not a "safe room" of solipsistic inwardness, but a site of responsibility for others. In the transcendental beyond, we are ordered toward the responsibility for the other. This responsibility, which Levinas calls the "otherwise than being," substitutes subjectivity (the self of the artist) for another: it becomes the other in the same.[7]

Tobi Kahn's sacred spaces and objects transcend their functional purpose. There is an aspect of this "otherwise than being" in all of his works. They are gifts that connect us tangibly to holiness and therefore to blessedness, to the responsibility for the other.

1 Theodor A. Adorno, *Aesthetic Theory*, trans. Robert Hullot-Kentor (Minneapolis: University of Minnesota Press, 1997), 135.

2 Pavel Florensky, *Iconostasis*, trans. Donald Sheehan and Olga Andrejev (New York: St. Vladimir's Seminary Press, 2000), 33.

3 The celebrated fifteenth-century icon painter and the subject of the 1966 film *Andrei Rublev* by the Russian filmmaker Andrei Tarkovsky.

4 Florensky, *Iconostasis*, 68.

5 Johann Wolfgang von Goethe, *Werke*, Hamburger Ausgabe in 14 Bänden (Munich: C. H. Beck, 1996), 1:366.

6 Immanuel Kant, *Critique of Pure Reason*, trans. N. K. Smith (New York: St. Martin's Press, 1965), 635 [B833].

7 Emmanuel Levinas, *Otherwise Than Being: Or Beyond Essence*, trans. Alphonso Lingis (Pittsburgh: Duquesne University Press, 1999).

Jeff Edwards

**THE MEASURE
OF AN INFINITE
OBJECT**

From behind its thoroughly modern façade, Tobi Kahn's art speaks in the ancient language of primal forces. In his works one can sense strong ties to a long progression of spiritual traditions that have always stressed the presence of the Absolute here and now, in this strange and often disappointing reality we inhabit. The idea that our fallen world is a mere (and only apparent) transformation of an all-pervasive divine self-existence has adopted numerous guises over the centuries, from the Upanishadic doctrine that all is Brahman, to Plotinus's concept of the emanation of everything from the One, to the assertion by the sixteenth-century German mystic Jacob Boehme in his massive alchemical exegesis of Genesis that creation only occurs when God undergoes illusory self-division in order to express his existential potential.[1] The story is told succinctly and powerfully in Lao Tzu's *Tao Te Ching*, the fundamental text of Taoism: "The Way gave birth to the One; the One gave birth to the Two; the Two gave birth to the Three; and the Three gave birth to the ten thousand things."[2]

The works in the current exhibition speak of the same story. In the practical purposes and mundane settings of Kahn's ritual objects we can see the ten thousand things of this busy world, while the flowing abstract forms that emerge from them reflect the hidden play of opposed forces behind visible reality. This endless play is not one of eternally hostile Manichean negations, but rather a dance of transient entities that define one another through their opposition. The simple, sharply defined shapes of Kahn's synagogue wall panels echo William Blake's cosmic dialectic, with its assertion that the intertwined tales of God and humanity cannot be told without the clash of contraries.[3] In their interdependence, the myriad things of this world always reach back toward the first moment when the great unity that preexisted creation made its inexplicable, miraculous leap into division and manifestation. Kahn's works show the same tension, begging the viewer to notice the contrast of their parts at one moment, and their seamless wholeness at another.

The sense of a more perfect order of things behind observable reality is a crucial element of Kahn's art. The smooth, sharp geometry and shiny surfaces of his Memorial lights (cat. nos. 11, 12 and 13) hint at perfect Platonic forms straining to burst into our shabby world of fallen matter from their own immutable realm. While some artists have suggested ideal forms by material absence—Fred Sandback's yarn-delineated areas of empty space come to mind—a piece like Kahn's eternal light PRIYA (cat. no. 10) suggests transmundane perfection through physical presence, via the precision of its angles, the lush metallic glow of its bronze surface, and its sheer sense of solid mass. Its symmetrical bowl and large angular base (inspired by the silhouette of a pomegranate) look as much like physical expressions of a mathematical formula as products of artistic vision. In contrast to the lack of the crude stuff of nature that one sees in Sandback's work, Kahn gives us that stuff in a more ordered and ideal form, vibrating from within with a sense of movement that challenges the distinctions we habitually draw between animate life and inert matter.

Many of Kahn's other surface effects help to enhance this sense of living power looming behind stillness. The movable parts of his Omer counter (*SAPHYR II*, cat. no. 24) eschew rigid symmetry and straight lines, seeming instead to twist and jostle as if pulsing from within with a life that yearns to express itself. The careful layering of paint on his canvases and wood panels creates vaguely luminous and subtly textured surfaces that look both organic and mineral at the same time. The surfaces of his best works have the ability to slow down one's viewing, in the same way that the calm precision of Martin Puryear's sculptures can coax one into a more serene, focused engagement.

Yet it is important to recognize that one cannot access the deepest levels of Kahn's creations via such surface effects alone. If these were the only important features of his works, it would be easy to misinterpret them as just another collection of modernist abstract art, made under the dictates of dusty formalist principles. The paradox of his imagery is that its dialogue with the absolute is visible to us because of the worldly context in which Kahn situates it. Kahn's works are social objects, and their intended use in specific religious and meditative contexts is what signals that there is more to them than mere old-school abstraction. Taken out of context and isolated within a traditional white-cube gallery space, any of the wall panels from his 2001 meditative room at the HealthCare Chaplaincy in New York (fig. 10) might be unfairly dismissed as a beautiful but familiar exercise in color field painting. It is their unapologetic self-identification as useful objects with a sacred purpose that goads us to find the hints of spirit that Kahn has embedded within his works.

Kahn always reminds us that the deepest and the most pedestrian levels of reality are inextricably linked. It's hard not to see a meandering river cutting its way through an arid landscape in *VYHTI* (cat. no. 7) or a magnified picture of blood cells in *SVIRH* (cat. no. 8), yet his recasting of these images as sharply defined two-color abstractions transforms them into glyphs of the eternal struggle between universal contraries that has worn so many different masks in the past. India's great scripture the *Bhagavad Gita* presents it as the partnership between *purusha* (omnipresent divine soul) and *prakriti* (basic matter) that brings the world to life. The *I Ching*, an ancient oracle and philosophical text that formed a cornerstone of Chinese culture up to the modern era, posits the eternal play of active and passive powers (Yin and Yang, heaven and earth) as the force that shapes every event and circumstance, no matter how great or small. The beautiful cosmic prologue of John's gospel speaks of the great struggle between the light and the darkness that mirrors our own endless choice between compassion and selfishness.

These stories and dozens more like them are all of a piece with the deeper narrative embedded within Kahn's art. The grand contest between these forces is reflected in every corner of our world, and this dance of opposites goes back to the first moment of creation; all things exist in an endless cycle of communion and conflict with the world around them. The stark horizon presented in *SHUVA* (cat.

no. 27) is as much a snapshot of the moment when God separated day and night and divided the primal waters as it is a reference to our place between heaven and earth.

The great mystical traditions assert that the highest levels of reality are as close as one's most immediate awareness, if only one has the eyes to see. Like all profound sacred art, Kahn's works present a powerful embodiment for this frustratingly elusive truth. Yet rather than relying upon allegory and symbolism to point at the divine, Kahn makes the bolder attempt to let eternal perfection speak for itself in its own language of forms and forces. As a result, he does more than just tell us stories about the divine heritage of humanity: he also invites us to sense the touch of divinity in everything we encounter.

1 Jacob Boehme, *Mysterium Magnum: An Exposition of the First Book of Moses Called Genesis*, trans. John Sparrow (San Rafael, CA: Hermetica, 2007), 1–5.
2 Robert G. Henricks, trans., *Lao-Tzu: Te-Tao Ching* (New York: Ballantine Books, 1989), 11.
3 William Blake, *The Marriage of Heaven and Hell* (London: Oxford University Press, 1975), plates 3, 16–17.

Daniel Sperber

SANCTITY

IN SPACE

Tobi Kahn is fascinated by, even obsessed with, the notion of space—not simply physical space but, much more, its spiritual dimension. His work reveals an ongoing struggle to express visually the abstracted component of sanctity in holy space.

In Jewish thought there are two kinds of holiness in space: the sanctity that people invest in a place of prayer and devotion to God, such as a synagogue, a *yeshiva* (a study hall), or perhaps even a cemetery. Such places have human-given sanctity. But there are also those areas with innate, God-given sanctity, such as the Land of Israel— the holiest of all lands, Jerusalem—the holiest of cities, the Temple in Jerusalem and its Holy of Holies—the holiest of all spaces in the world.

Objects, such as a Torah scroll, the ark of the Law, even the *bimah* (the table on which the Torah scroll is placed to be read before the community), can also be endowed with sanctity. Among ceremonial objects, too, there are gradations of holiness; the Torah scroll, for example, is holier than its *mantel* or cover, or its breastplate and finials.

Such gradations, which function in human- as well as God–conferred sanctity, are analogous to the ripple effect in water. When we throw a stone into a pond, the ripples in the center are very distinct. As they move farther away from the center, there is a diminution in their clarity. So, too, there are circles of divine emanation, concentric levels of sanctity. There are great concentrations in some areas, along with the sense that increased distance from them creates a regressive continuum of sanctity. This attribute, in kabbalistic terminology, is called *tzimtzum*, which might be translated as "diminishment."

How, then, can one express visually these spiritual, even mystical concepts? Some of Kahn's aerial views, with their abstracted contours—at times curvilinear, Jordan- like, at times more Rorschach-like—seek to portray the ethereality of the dimension of holiness in the landscape of Israel, in sacred space.

Among his ceremonial objects for the synagogue are those that include the aerial landscape motifs, suggesting or implying Godly sanctity in these ritual articles (cat. nos. 7 and 9). Many evoke a circumscribed space, open, partly or completely enclosed. Thus, two- columned portals can be entered, passed through into expectant, undefined space; four- pillared, altar-like objects describe and delineate the perimeters of sanctified space; and a truncated pyramid base structure seems to support a receptacle for sanctity (cat. no. 11).

Art and architectural motifs coalesce in Kahn's small ritual objects, as well as in the broader architectonic vision of his installations. Note that the synagogue, with its airy windows and aerial views, is both open to outside light and an enclosed area of holiness (see fig. 3).

Kahn's objects, his organization of space—with all their minimalist departure from what would appear to be traditional forms—remain ritually utilitarian and thus do not go beyond the parameters of normative Jewish tradition. However, the utilitarian aspects are underplayed, almost disguised by the overall composition, by associative motifs, and by the search for representation of the spiritual in the material. As such, Kahn's works express deep religiosity without any of its attendant banality— they are both subtly intellectual and spiritually sublime.

SONG OF THANKSGIVING

Eve to dawn of day, may these, our words,

of prayer and praise, and this, beauty hallowed,

be a dwelling place where we can offer up our

changing light, radiant, dappled, darkening,

to be received with constant love, with grace,

so that, beneath Your sheltering wing, we pledge

ourselves to hospitality, seeking peace beyond

and peace within, Your harmony descending,

Your light, steadfast, unending.

Vessel of tenderness, harvest nestling, rapt, immanent, aurora hallowing,
astral light of Your jubilant mercy.

1 JHYA 2008

Acrylic on canvas over wood
72⅛ × 45⅛ × 2⅝ in.

Inward, intimate, lattice of harmony, quickening compass, serene affinity, cradled in Your nascent symmetry.

2 LHAYD 2008

Acrylic on canvas over wood
72⅛ × 45⅛ × 2⅝ in.

Catalog

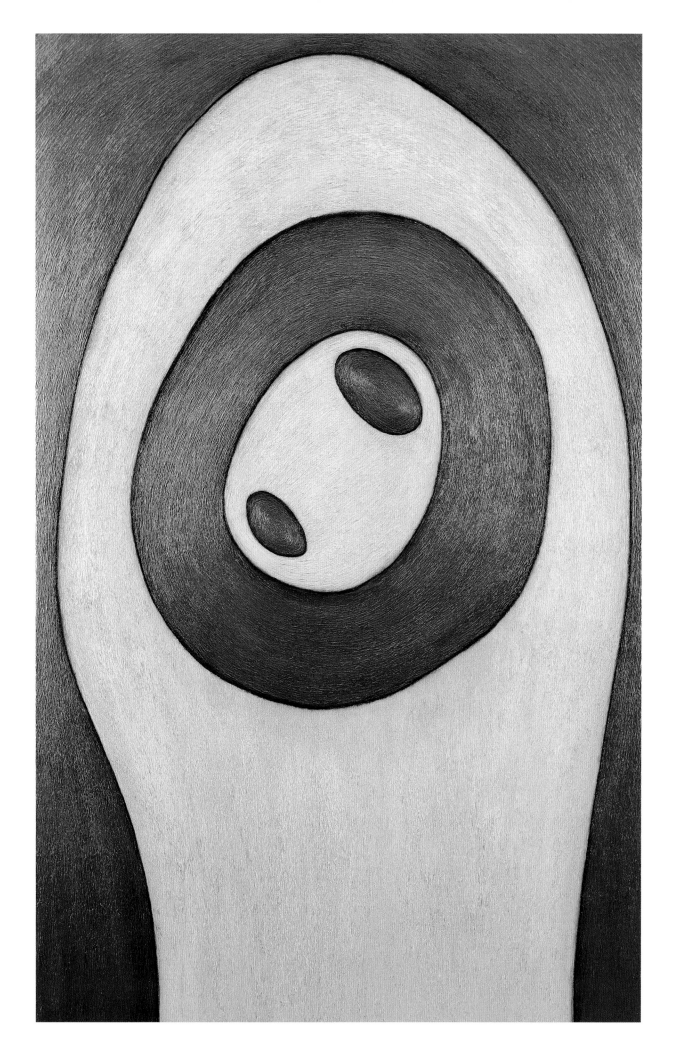

Arching to ornament, jeweled lucidity, imbued, imageless, arabesque kinship, animate constancy.

3 KYNH 2008

Acrylic on canvas over wood
72⅛ × 45⅛ × 2⅝ in.

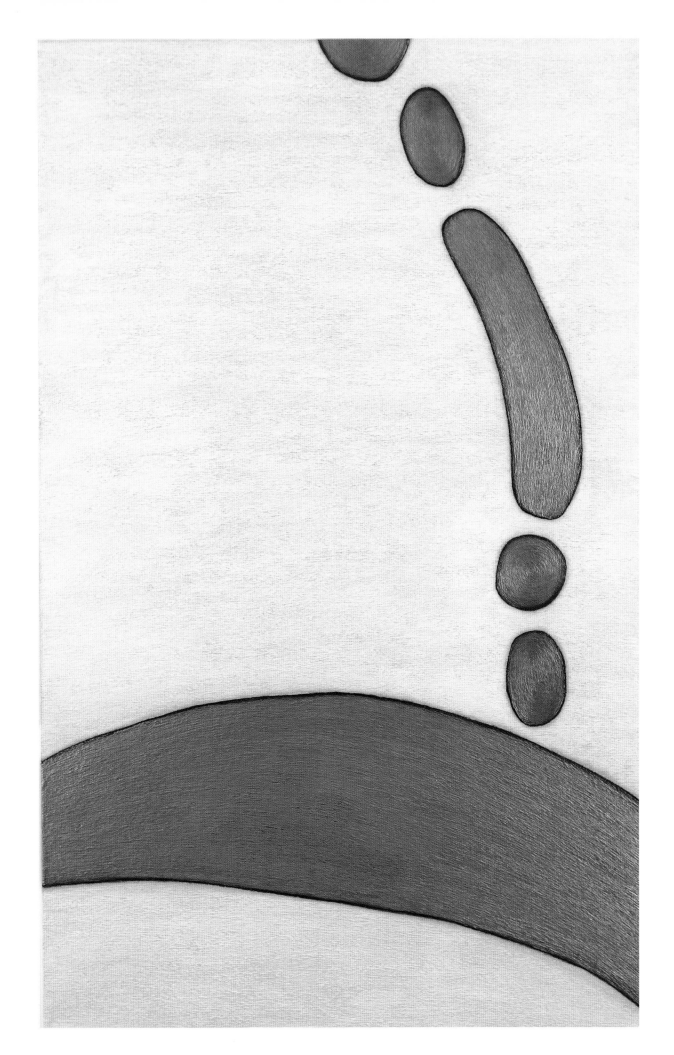

Rooted in firmament, springing fidelity, cleaved, inflorescent, cascade of fruitfulness, cornet of glory.

4 AARAH 2008

Acrylic on canvas over wood
72⅛ × 45⅛ × 2⅝ in.

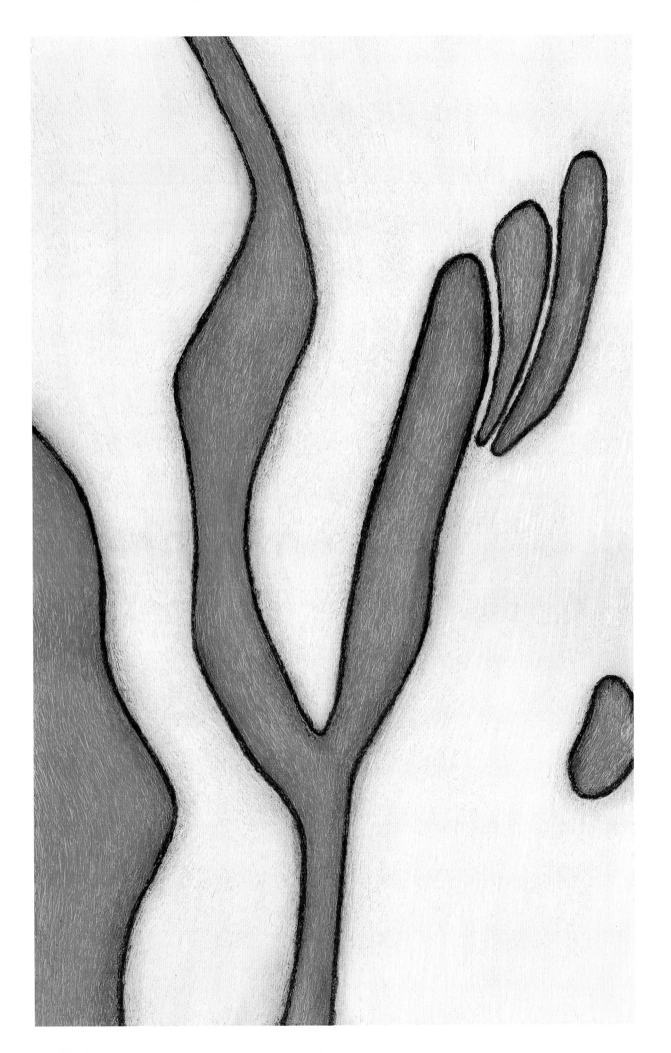

5 YMKHA 2008

Ark doors

Acrylic on wood
62 × 28 × 4 in.

First light, assembled in gold embrace, hosanna, lucent sanctuary, poured song of ascending praise.

6 **QYNTA** 2008

Acrylic on canvas over wood
72⅛ × 45⅛ × 2⅝ in.

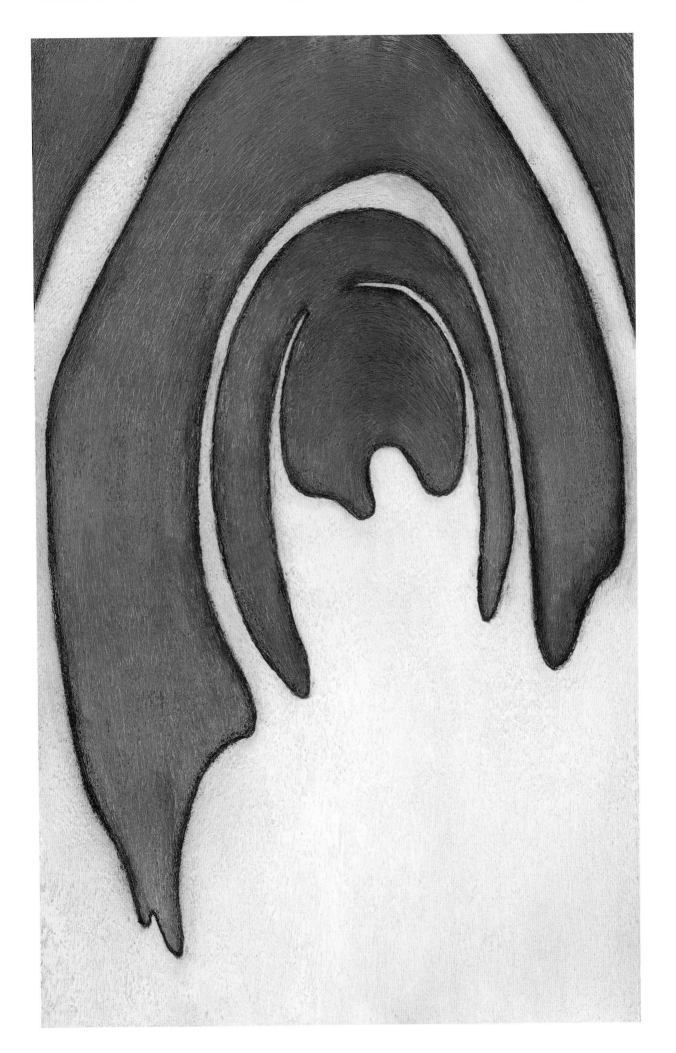

Toward, to You, fluent dwelling place, spiraling source of amplitude and grace, only, ever, always.

7 VYHTI 2008

Acrylic on canvas over wood
72⅛ × 45⅛ × 2⅝ in.

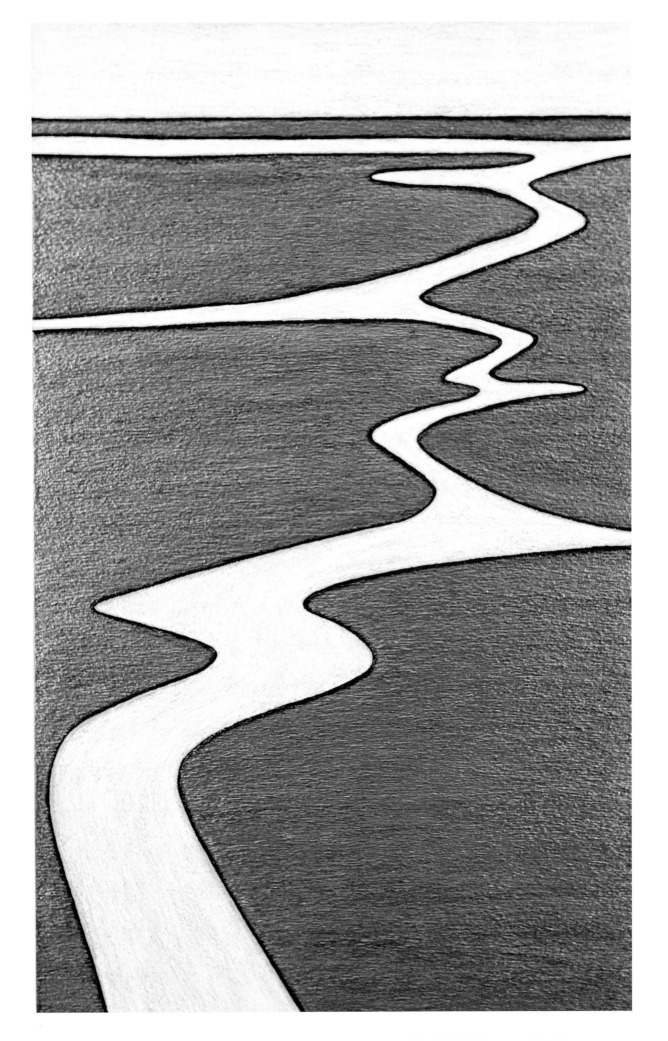

One, entire, unbound as You are, wed to us, lumina, condensed infinity,
revel of plenitude, dawn star.

8 SVIRH 2008

Acrylic on canvas over wood
72⅛ × 45⅛ × 2⅝ in.

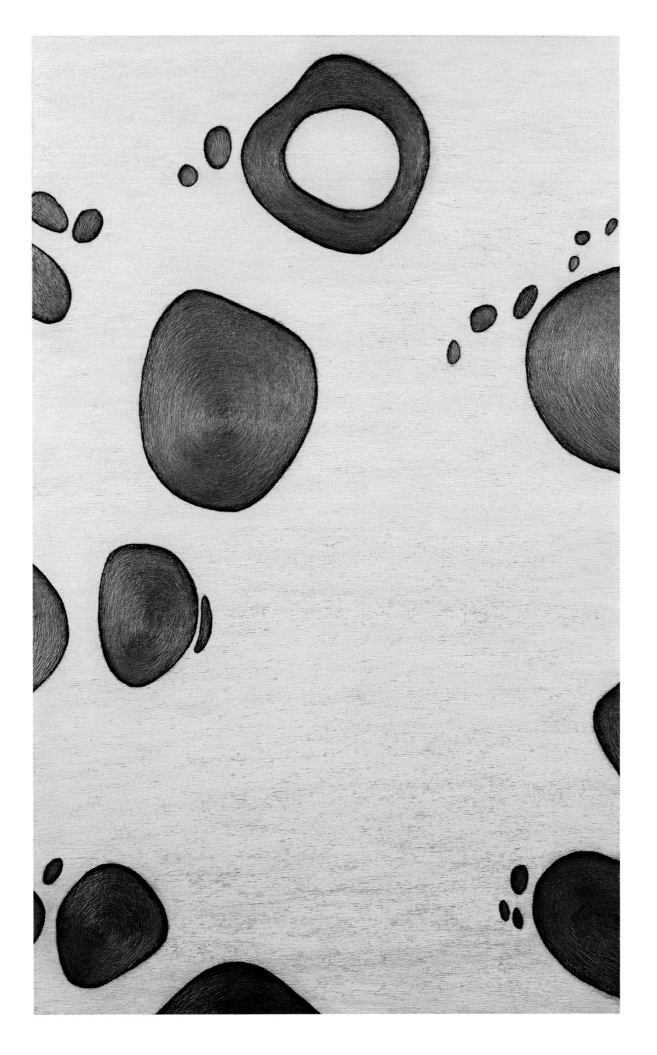

Pooling pulse, replenishing, lustrous reverie, gather, glean, brimming edge
of intermingling, aerial eternity.

9 MIPHRA 2008

Acrylic on canvas over wood
72⅛ × 45⅛ × 2⅝ in.

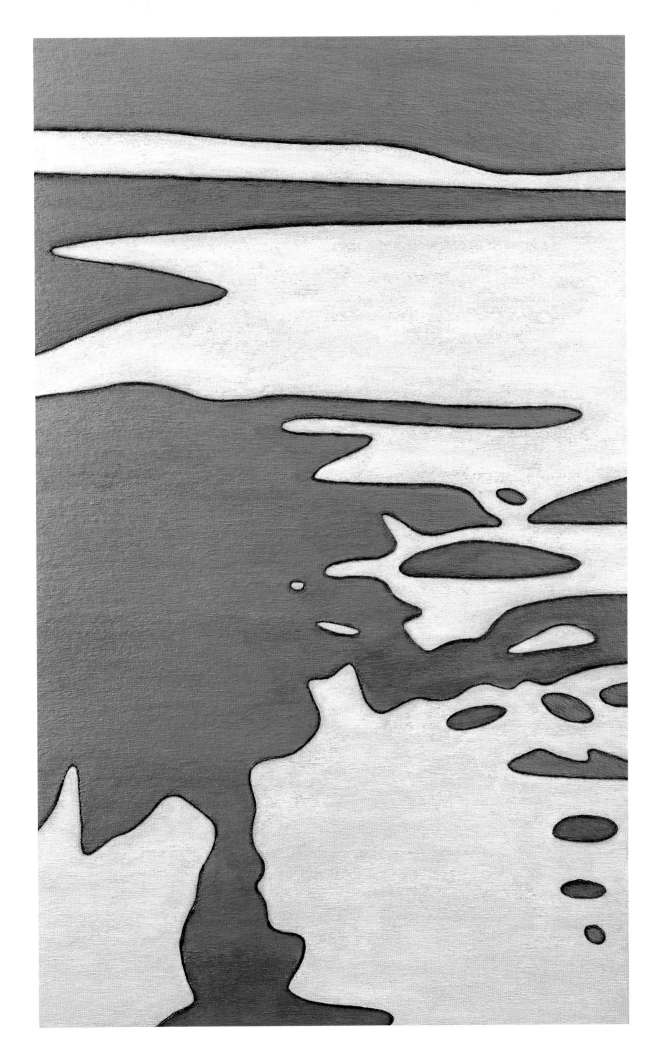

10 PRIYA 2008

Eternal light

Bronze
12 × 12 × 8½ in.

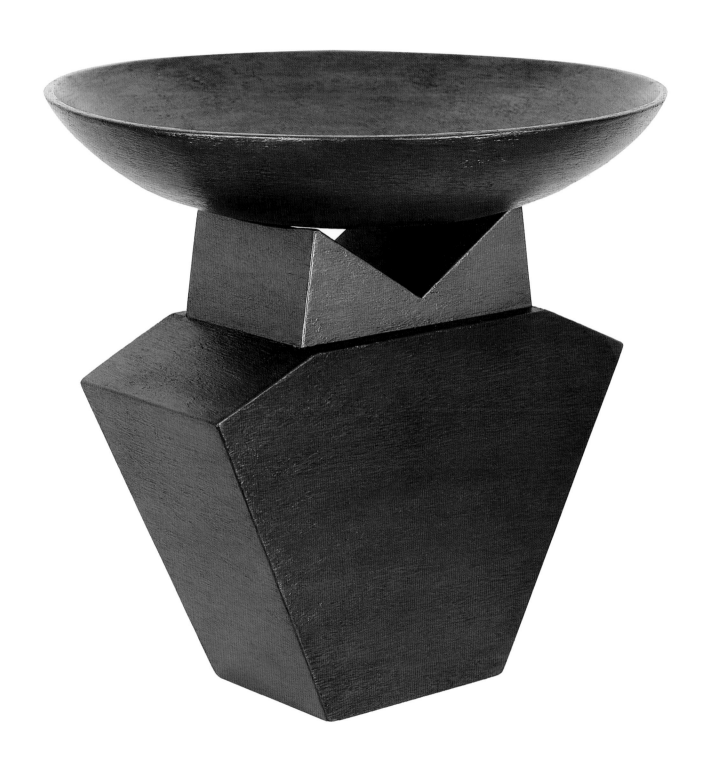

11 LAHAV VI 2008

Acrylic on wood
7¾ × 8½ × 8½ in.

12 LAHAV V 2008

Acrylic on wood
5¹⁄₁₆ × 6⅛ × 6⅛ in.

13 LAHAV IV 2008

Acrylic on wood
6¾ × 7¾ × 7¾ in.

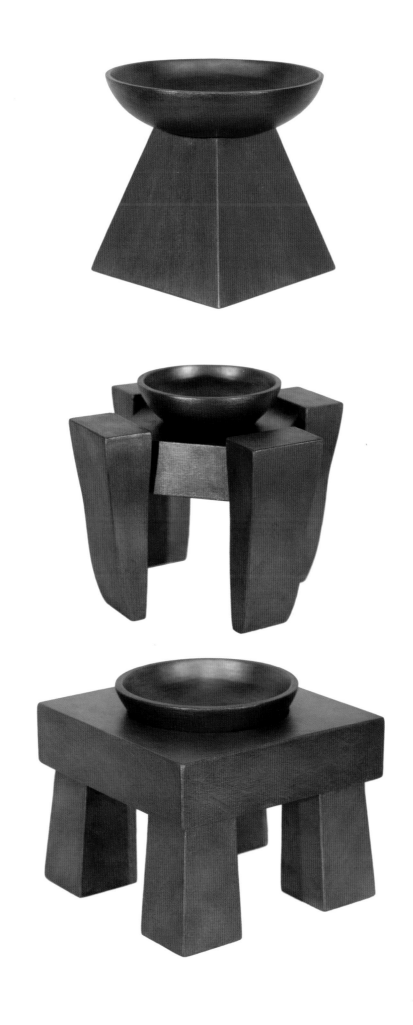

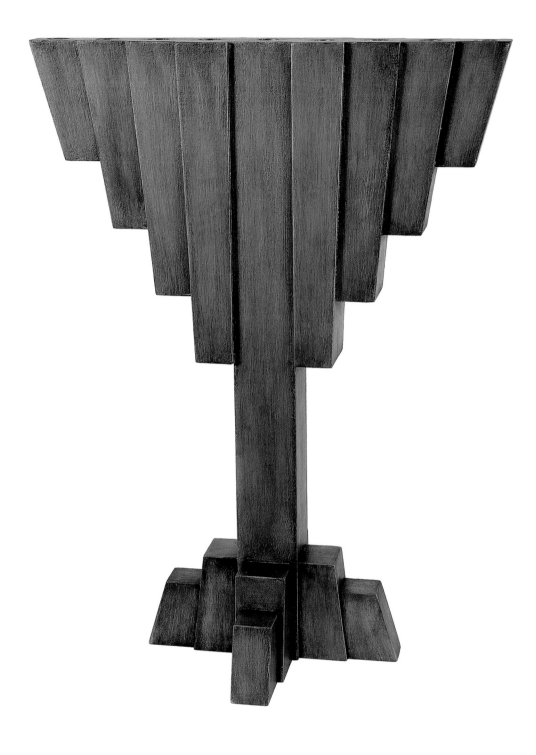

14 QUYA III. VARIATION II. 2008

Menorah

Acrylic on wood
48½ × 37 × 20 in.

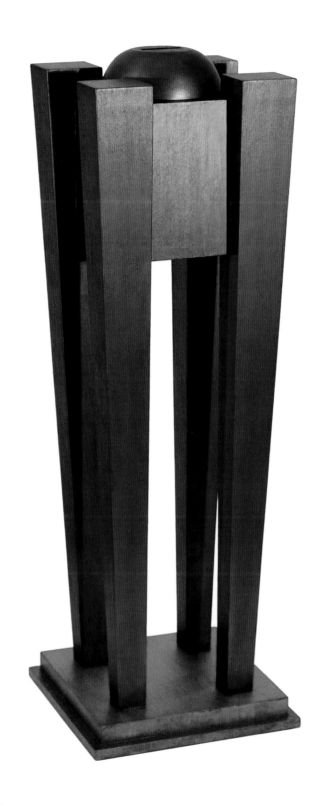

15 DAHKA 2008

Charity box

Acrylic on wood
49½ × 16¾ × 16¾ in.

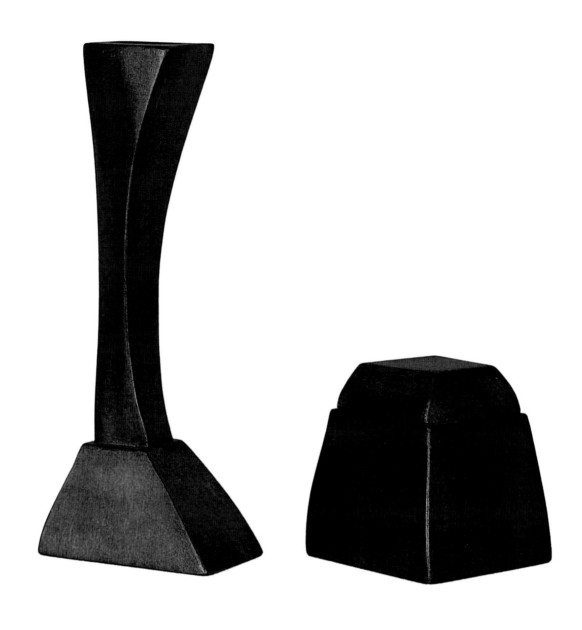

18 YKARH III 2008

Havdalah candlestick holder
Acrylic on wood
10⅛ × 2¾ × 4³⁄₁₆ in.

Spice box
Acrylic on wood
4⅜ × 3¾ × 3¾ in.

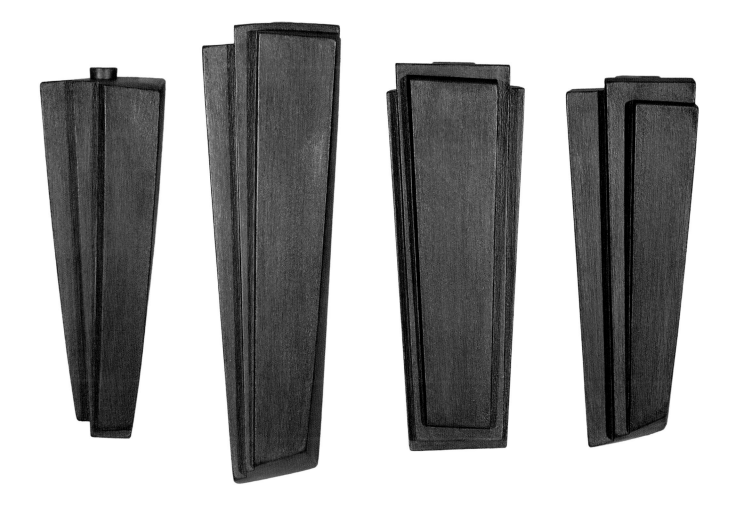

19 MEZUZOT 2008

set of four

Acrylic on wood
dimensions vary

21 OHRENH II 2009

Torah breastplate

Acrylic on wood
10⁹⁄₁₆ × 8½ × 1¾ in.

22 OHRENH III 2009

Torah breastplate

Acrylic on wood
10⁹⁄₁₆ × 8½ × 1¾ in.

23 OHRENH IV 2009

Torah breastplate

Acrylic on wood
10⁹⁄₁₆ × 8½ × 1¾ in.

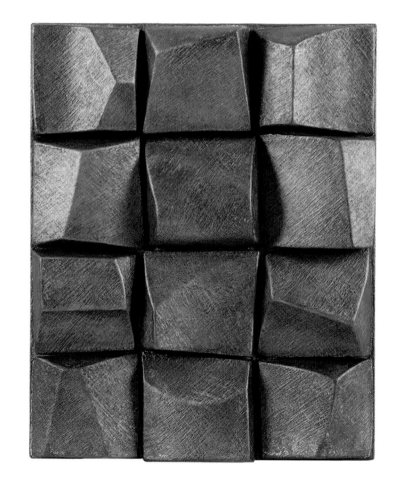

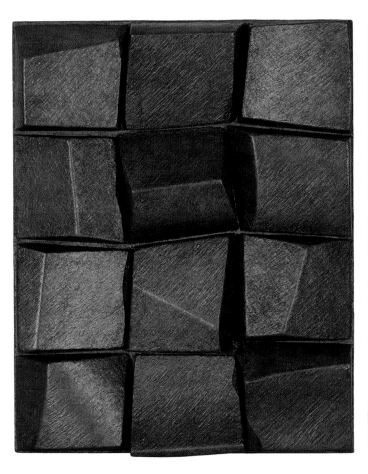

SONG OF ASCENT

Springing to harvest, freedom concealed

in slavery, lovingkindness in captivity,

lead us from severity through the parting sea,

lover of beauty, dancer exultant, splendor

in majesty, from the veiled day in which

we began, until, founded, encompassing,

we wait anew for blazing revelation.

24 SAPHYR II 2004

Omer counter

Acrylic on wood
72⅝ × 58⅝ × 24¹¹⁄₁₆ in.

SONG OF BEGINNING

Daughter of our mothers, enter the covenant of community, raised to a life of laughter, fortitude, tenderness, fertility, replete with blessing and wellbeing, shaped by devotion, without shame or transgression, and may the merciful One who rendered miracles redeem us soon and gather all who are dispersed from the four corners of the earth, bound to one another, living waters, and may you wear the crown of a good name, and be anointed with the perfume of the Land, cloves and cinnamon, rose petal, ginger, pomegranate leaves and cardamom, and may you be, like Sarah, Rebecca, Rachel and Leah, protected, the Creator's light upon you, favoring you, bestowing peace, the One who gave us life, sustaining, allowing us to reach this festive day.

25 AHMA 2008

Shalom Bat chairs

Acrylic on wood, each
70⅜ × 20⁷⁄₁₆ × 26⅜ in.

Commissioned by Shaykin Family
Foundation for the Abraham Joshua
Heschel School, New York, NY.

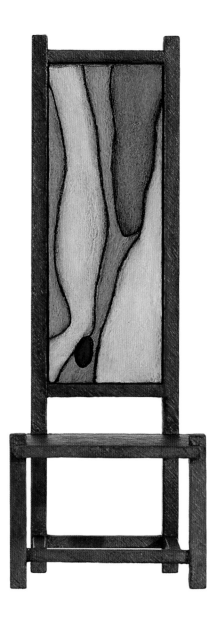

Catalog

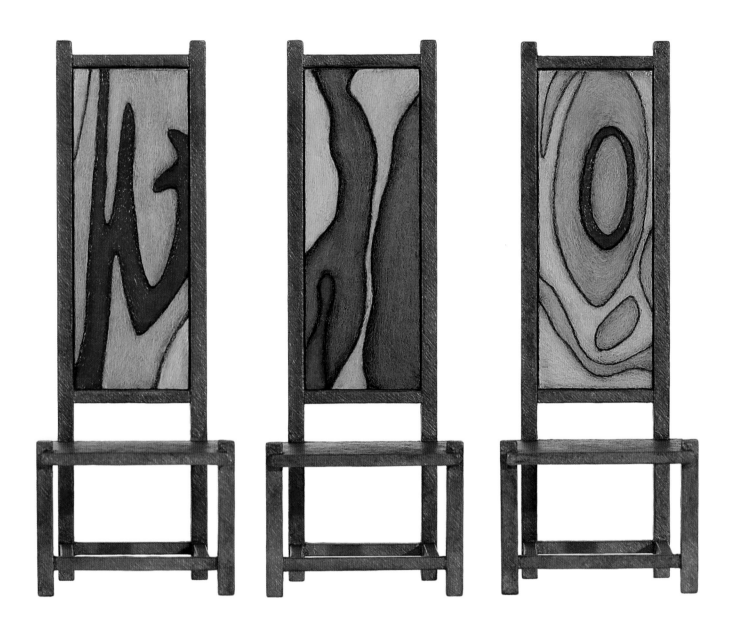

SONG OF SUPPLICATION

Lord, who will tell dusk from dawn, find the horizon between our anguished hour and the clarity of Your pristine creation. Who will divide returning dust from memory revived, secure our faltering, promise that the receding past will, recalled, hasten to us, abiding. Ease our bewildered cry, convert rift to sanctuary, command the reunion, speedily, of earth and sky, desert and paradise.

26 KRI'AH 2009

Acrylic on wood
55 × 17 × 4½ in.

Plaza Jewish Community Chapel

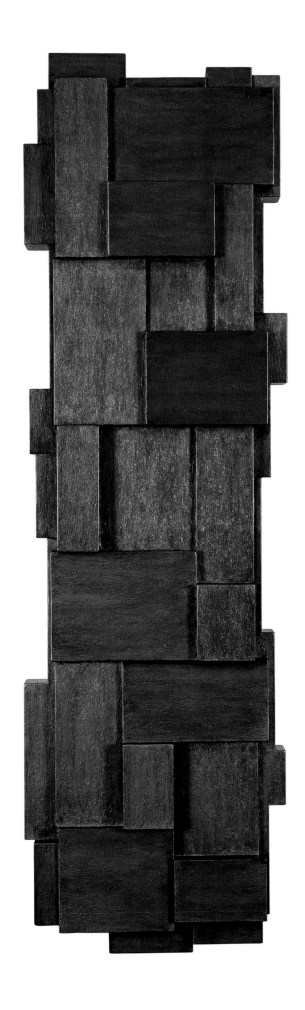

27 SHUVA 2009

Acrylic on canvas over wood
20⅛ × 61⅛ × 2¾ in.

Plaza Jewish Community Chapel

28 **YTKHA** 2009

Acrylic on wood
49⅝ × 13½ × 13½ in.

Plaza Jewish Community Chapel

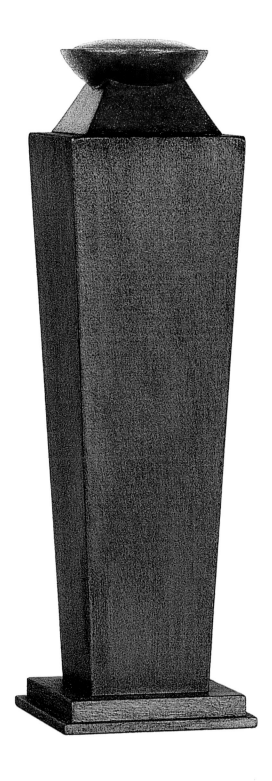

SONG OF REDEMPTION

Beside me, protector, before me, restoring the world, healer, around me, harbor, holy, behind me, refuge, above, pure, presiding love.

29 SHALEV 1994

(model)

Bronze
8⅛ × 6 × 3¾ in.

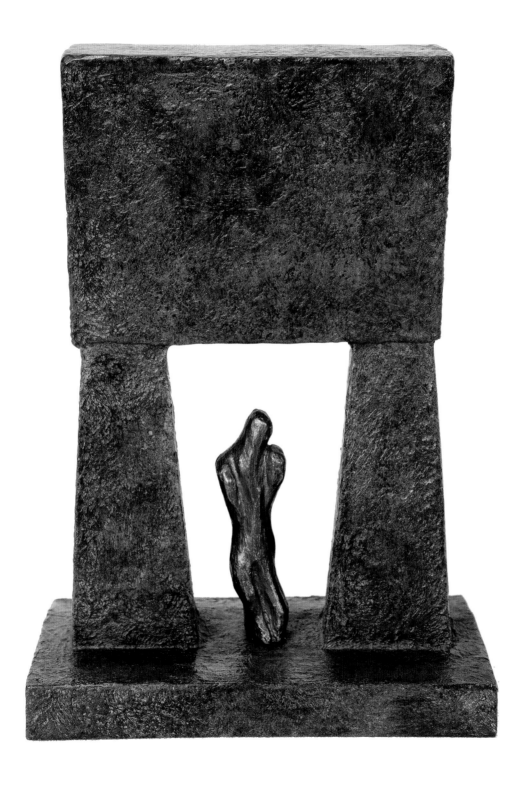

SONG OF RETURN

Breath floating above the water, let there be light, at the birth of evening and the rising day, let there be praise, sanctuary of sky and cradling sea, listening, the gathering dusk radiant with thanksgiving.

30 EMET 2001

Meditative space
HealthCare Chaplaincy, New York, NY

Acrylic, canvas and wood

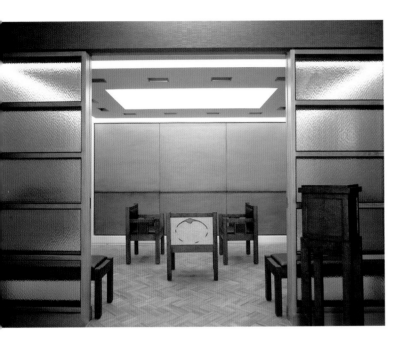
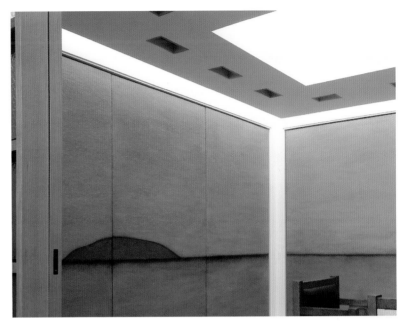
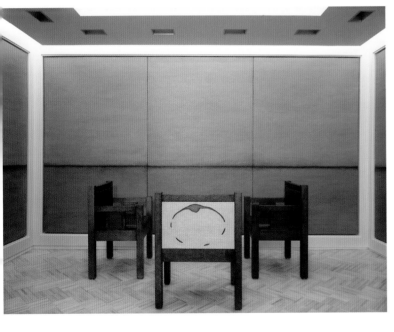
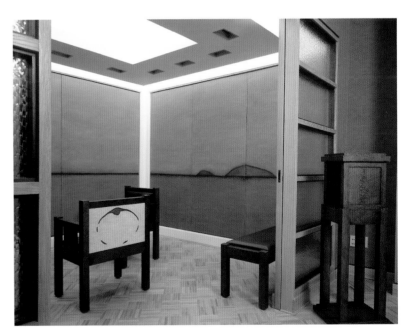

BIOGRAPHY

Born in New York, NY, 1952. Lives in New York, NY.

Education

Hunter College, New York, NY, BA, 1974–76
Pratt Institute, New York, NY, MFA, 1976–78

Selected Solo Exhibitions

2009 Tobi Kahn: Sacred Spaces for the 21st Century, Museum of Biblical Art, New York, NY (catalog)
Thresholds, Library Gallery of the Jewish Theological Seminary, New York, NY

2007 Tobi Kahn Recent Paintings, Harmon-Meek Gallery, Naples, FL

2006 Materia: Tobi Kahn Recent Works, Works on Paper, Philadelphia, PA
Tobi Kahn: Metamorphoses Revisited, Beauregard Fine Art, Rumson, NJ

2005 Sanctuary in the Age of Commodity: The Art of Tobi Kahn, curated by Peter Selz, Museum of Craft and Folk Art, San Francisco, CA

2004 Tobi Kahn Reflections, curated by David Morgan, Brauer Museum of Art, Valparaiso University, Valparaiso, IN (catalog)

2003 Paradisus: Paintings by Tobi Kahn, a two-year traveling museum exhibition curated by Mark White, Gardiner Art Gallery, Oklahoma State University, Stillwater OK (catalog)
Tobi Kahn: Works from the Cape, Cape Museum of Fine Arts, Dennis, MA
Sky and Water Paintings, curated by Dede Young, Neuberger Museum of Art, Purchase, NY (catalog)

2002 Microcosmos, curated by Reba Wulkan, Yeshiva University Museum, New York, NY (catalog)

2001 Tobi Kahn: Heads, curated by Peter Selz, Rubelle and Norman Schafler Gallery, Pratt Institute, Brooklyn, NY (catalog)

2000 Tobi Kahn: Correspondence, a two-year traveling museum exhibition, curated by Mark White, organized by the Edwin A. Ulrich Museum of Art, Wichita, KS (catalog)
Harmon-Meek Gallery, Naples, FL

1999 Landscape at the Millennium, curated by Douglas Dreishpoon, Albright-Knox Art Gallery, Buffalo, NY (catalog)
Avoda: Objects of the Spirit, a five-year traveling museum exhibition, curated by Laura Kruger, opened at Hebrew Union College, New York, NY (catalog)

1998 Hooks-Epstein Galleries, Houston, TX
Andrea Marquit Fine Arts, Boston, MA

1997–99 Metamorphoses: Tobi Kahn, a traveling museum exhibition, curated by Peter Selz, at Weatherspoon Art Gallery, Greensboro, NC; Trout Gallery, Carlisle, PA; MOCRA, St. Louis, MO; Thomas J. Walsh Art Gallery, Fairfield, CT; Colby College Museum of Art, Waterville, ME; Museum of Fine Arts, Houston, TX; Judah L. Magnes Museum, Berkeley, CA; Skirball Museum, Los Angeles, CA (catalog)

1997 Landscapes of the Mind, M. Louise Aughinbaugh Gallery, Grantham, PA
Mary Ryan Gallery, New York, NY
Seduction of Memory: Paintings by Tobi Kahn, Hyde Collection, Glens Falls, NY

1996 Warehouse Gallery, Lee, MA
Harmon-Meek Gallery, Naples, FL

1995 Mary Ryan Gallery, New York, NY
Andrea Marquit Fine Arts, Boston, MA

1994 Allene Lapides Gallery, Santa Fe, NM

1993 Mary Ryan Gallery, New York, NY
Thomson Gallery, Minneapolis, MN
Cleveland Center for Contemporary Art, Cleveland, OH
Litwin Gallery, Wichita, KS

1992	Gloria Luria Gallery, Bay Harbor Islands, FL
1991	Mary Ryan Gallery, New York, NY
1990	Gloria Luria Gallery, Bay Harbor Islands, FL
	Marilyn Butler Fine Art, Scottsdale, AZ
1989	Althea Viafora Gallery, New York, NY
1988	Harcus Gallery, Boston, MA
	Cleveland Center for Contemporary Art, Cleveland, OH
	Mary Ryan Gallery, New York, NY
	Gloria Luria Gallery, Bay Harbor Islands, FL
1987	Althea Viafora Gallery, New York, NY
	Krygier/Landau Contemporary Art, Los Angeles, CA
	John Berggruen Gallery, San Francisco, CA
1986	Althea Viafora Gallery, New York, NY
1985	Bernard Jacobson, Los Angeles, CA
1984	Althea Viafora Gallery, New York, NY
1983	Althea Viafora Gallery, New York, NY
1981	Blumberg Harris, New York, NY
1980	Robert Brown, New York, NY
1979	Fordham University, New York, NY
1978	Pratt Institute Gallery, Brooklyn, NY

Selected Group Exhibitions

2008	Pursuit of the Spirit, Museum of Contemporary Religious Art (MOCRA), St. Louis, MO *(catalog)*
2007	Golf in American Art, curated by Bill Meek, Von Liebig Art Center, Naples, FL *(catalog)*
2006	Making It New: George McNeil & His Students, Montserrat College of Art, Beverly, MA *(catalog)*
	From Sea to Shining Sea: America through Our Eyes, curated by Ori Z. Soltes, DC Arts Center, Washington, DC *(catalog)*
2005	Mining the Collection: Recent Acquisitions, Yeshiva University Museum, New York, NY
2004	Waldsee, 2B Galeria, Budapest, Hungary (traveling)

2001	At the Edge: The Horizon Line in Contemporary Art, curated by Donna Harkavy and Margaret Matthews-Berenson, Dorsky Gallery, New York, NY *(catalog)*
	Like a Prayer, curated by Theodore L. Prescott, Tryon Center of Visual Arts, Charlotte, NC *(catalog)*
2000	Cross-Currents in Modern Art, A Tribute to Peter Selz, Achim Moeller Fine Art, New York, NY *(catalog)*
	Ethereal & Material, curated by Dede Young, Delaware Center for Contemporary Art, Wilmington, DE *(catalog)*
1999	Highlights from the Dillard Collection of Art on Paper, curated by Douglas Dreishpoon, Weatherspoon Art Gallery, Greensboro, NC *(catalog)*
	Waxing Poetic, Montclair Art Museum, Montclair, NJ and Knoxville Museum of Art, Knoxville, TN *(catalog)*
1997	Vertical Painting, curated by Alanna Heiss, P.S.1 Contemporary Art Center, Long Island City, NY
1996	The Figure in 20th Century Sculpture, Edwin A. Ulrich Museum of Art, Wichita, KS. Traveled to eleven venues in the United States.
	Destiny Manifest: American Landscape Painting in the Nineties, Samuel P. Harn Museum of Art, Gainesville, FL *(catalog)*
1995	Art on Paper, Weatherspoon Art Gallery, Greensboro, NC
	Never Again, curated by Noga Garrison, Cathedral of St. John the Divine, New York, NY
	Painting North, Art in Embassies, U.S. Department of State, American Embassy, Santiago, Chile *(catalog)*

1993 Timely Timeless, curated by Douglas Maxwell, Aldrich Museum, Ridgefield, CT *(catalog)*
 25 Years, curated by Majorie Talalay, Cleveland Center for Contemporary Art, Cleveland, OH
 Aspects of Sculpture, curated by Donald Knaub, Edwin A. Ulrich Museum of Art, Wichita, KS
 Sanctuaries: Recovering the Holy in Art, MOCRA, Saint Louis University, St. Louis, MO

1992 Off the Wall, Cleveland Center for Contemporary Art, Cleveland, OH
 ECO-92, Museum of Modern Art, Rio de Janeiro, Brazil *(catalog)*
 Contemporary American Painting and Sculpture, curated by Louise Eliasof, Andre Emmerich Gallery, and Renne Du Pont Harrison, Art in Embassies, U.S. Department of State, American Embassy, Tel Aviv, Israel

1991 Retrieving the Elemental Form, Schmidt-Bingham Gallery, NY. Traveled to Lakeview Museum of Arts and Science, Peoria, IL; and Fresno Art Museum, Fresno, CA *(catalog)*
 Playing Around: Toys by Artists, DeCordova Museum, Lincoln, MA

1990 Southeast Bank Collects: A Florida Corporation Views Contemporary Art. Traveled to Norton Gallery of Art, West Palm Beach, FL; Bass Museum of Art, Miami Beach, FL; Museum of Fine Arts, St. Petersburg, FL; Polk Museum of Art, Lakeland, FL; Samuel P. Harn Museum of Art, Gainesville, FL *(catalog)*
 Contemporary Landscape, A.B.C., The Art Advisors, Museum of Modern Art, New York, NY
 Insistent Landscapes, Security Pacific Gallery, Los Angeles, CA *(catalog)*

1989 Contemporary Landscape: Five Views, curated by J. Moore, Waterworks Visual Arts Center, Salisbury, VA *(catalog)*
 Monotypes, Cleveland Center for Contemporary Art, Cleveland, OH

1988 Art on Paper, Weatherspoon Art Gallery, Greensboro, NC
 Dia de los Muertos, Alternative Museum, New York, NY *(catalog)*
 Off the Wall, Cleveland Center for Contemporary Art, Cleveland, OH
 Golem! Danger, Deliverance and Art, The Jewish Museum, New York, NY *(catalog)*
 Annual Juried Show, curated by Irving Sandler, Queens Museum, NY

1987 Emerging Artists 1978–1986: Selections from the Exxon Series, curated by Diane Waldman, Solomon R. Guggenheim Museum, New York, NY
 Masters of Ceremony: Designers of New Judaica, curated by Gayle Weiss, Klutznick Museum, Washington, DC
 The New Romantic Landscape, Whitney Museum of American Art, Fairfield County Branch, Stamford, CT
 Sacred Spaces, curated by Dominique Nahas, Everson Museum of Art, Syracuse, NY *(catalog)*
 Contemporary American Landscape: Reflections of Social Change, curated by Nancy Cohen, Kiku Fukui and Liz Kelsey, Summit Art Center, Summit, NJ

1986 Anchorage/New York: Small Sculpture, Visual Arts Center of Anchorage, Anchorage, AK
 Jewish Themes: Contemporary American Artists Part II, curated by Susan T. Goodman, The Jewish Museum, New York, NY *(catalog)*

Landscape in the Age of Anxiety, curated by
Nina Castelli Sundell, Lehman Art College,
Bronx, NY. Traveled to Cleveland Center for
Contemporary Art, Cleveland, OH *(catalog)*
A View of Nature, curated by Ellen O'Donnell,
Aldrich Museum, Ridgefield, CT

1985 Contemporary Sculpture on a Pedestal,
curated by Susan L. Halper. Traveled to Moody
Gallery, University of Alabama, AL; University
Galleries, University of South Florida;
Huntsville Museum of Art, Huntsville, AL
(catalog)
New Horizons in American Art: 1985 Exxon
National Exhibition, curated by Lisa Dennison,
Solomon R. Guggenheim Museum, New York,
NY *(catalog)*
The Doll and Figurine Show, Hillwood Art
Gallery, Long Island University, NY *(catalog)*
Drawings, Cleveland Center for
Contemporary Art, Cleveland, OH
Between Drawing and Sculpture, curated by
Douglas Dreishpoon, The Sculpture Center,
New York, NY

1981 Queens Museum, Queens, NY

Collaborations and Commissions

Sanctuary Installation—eight murals and ceremonial
objects, Congregation Emanu-El B'ne Jeshurun,
Milwaukee, WI, 2009
Chapel Installation—painting and sculpture, Plaza
Jewish Community Chapel, New York, NY, 2009
Shalom Bat Chairs, Abraham Joshua Heschel School,
New York, NY, 2008
Meditative Space/Chapel, Temple Beth El of Northern
Valley, Gloster, NJ, 2007
Eternal Light, Israelitische Kultusgemeinde, Munich,
Germany, 2006
Wall Installation, Congregation Sinai, Milwaukee,
WI, 2006
Lobby Installation—five-panel painting, UJA-
Federation of New York, New York, NY, 2006
Meditative Space/Chapel, Zicklin Hospice Residence,
Riverdale, NY, 2005
Biblical Women—installation of nine paintings, Yula
Girls High School, Los Angeles, CA, 2005
Meditative Room, HealthCare Chaplaincy,
New York, NY, 2002
YYRA, outdoor sculpture, Edwin A. Ulrich Museum of
Art, Wichita, KS, 2001
Holocaust Memorial Garden, Lawrence Family Jewish
Community Center of San Diego County, La Jolla, CA,
2000
Gan Hazikaron: Garden of Remembrance, outdoor
installation of six bronzes, Holocaust memorial, for
Jewish Community Center on the Palisades, 1997
Entrance Mezuzah, Museum of Jewish Heritage,
Battery Park City, NY, 1997
The Twelve Tribes and Creation of the World—paintings
and ceremonial objects, Jewish Family Congregation,
South Salem, NY, 1995

Shalev, outdoor sculpture, commissioned by Jane
 Owen and the Robert Lee Blaffer Trust for New
 Harmony, IN, 1993
Ways, Shrines, Mysteries, Muna Tseng Dance Projects,
 choreographed and danced by Muna Tseng, music by
 Mieczyslaw Litwinski, sculpture set by Tobi Kahn,
 Florence Gould Hall, New York, NY, 1990
Jonah, directed by Elizabeth Swados, sculpture set by
 Tobi Kahn, Public Theater, New York, NY, 1990
Aluht-El, dance by Muna Tseng, sculpture set by Tobi
 Kahn, Echofest: A Celebration of Rare and
 Endangered Species, Riverside Park, City of New York
 Department of Parks and Recreation, 1989
Song of Songs, directed by Elizabeth Swados, set by Tobi
 Kahn, Central Synagogue, New York, NY, 1989
Aspen Grove, Solomons Dance Company, choreography
 by Gus Solomons Jr., sculpture set by Tobi Kahn,
 music by Toby Twining, Joyce Theater, New York, NY,
 1988
Bone Yard, Solomons Dance Company, choreography by
 Gus Solomons Jr., sculpture set by Tobi Kahn, music
 by Jalalu Nelson, St. Marks Church, New York, NY,
 1988

Selected Public and Corporate Collections

Museum of Fine Arts, Houston, TX
Solomon R. Guggenheim Museum, New York, NY
The Jewish Museum, New York, NY
Edwin A. Ulrich Museum of Art, Wichita, KS
Colby College Museum of Art, Waterville, ME
Weatherspoon Art Gallery, Greensboro, NC
Museum of Art, Fort Lauderdale, FL
Rose Art Museum, Boston, MA
Fort Wayne Museum, Fort Wayne, IN
Skirball Cultural Center, Los Angeles, CA
Brauer Museum of Art, Valparaiso, IN
Minneapolis Institute of Art, Minneapolis, MN
Neuberger Museum of Art, Purchase, NY
Pennsylvania Academy of the Fine Arts (from Vogel
 Collection), Philadelphia, PA
Progressive Corporation, Cleveland, OH
Mitchell and Company, Boston, MA
Exxon Corporation, Miami, FL
Chase Manhattan Bank, New York, NY
Prudential Insurance, New York, NY
Swiss Bank Corp., New York, NY
Dreyfus Corp., New York, NY
Fidelity Investments Corporation, Boston, MA

Awards

2007	Honorary Doctorate, Jewish Theological Seminary, New York, NY
2004	Cultural Achievement Award for the Visual Arts, National Foundation for Jewish Culture, New York, NY
2000	Alumni Achievement Award, Pratt Institute, Brooklyn, NY

CHECKLIST

1. Jhya, 2008. Acrylic on canvas over wood, 72⅛ × 45⅛ × 2⅝ in.

2. Lhayd, 2008. Acrylic on canvas over wood, 72⅛ × 45⅛ × 2⅝ in.

3. Kynh, 2008. Acrylic on canvas over wood, 72⅛ × 45⅛ × 2⅝ in.

4. Aarah, 2008. Acrylic on canvas over wood, 72⅛ × 45⅛ × 2⅝ in.

5. Ymkha, Ark doors, 2008. Acrylic on wood, 62 × 28 × 4 in.

6. Qynta, 2008. Acrylic on canvas over wood, 72⅛ × 45⅛ × 2⅝ in.

7. Vyhti, 2008. Acrylic on canvas over wood, 72⅛ × 45⅛ × 2⅝ in.

8. Svirh, 2008. Acrylic on canvas over wood, 72⅛ × 45⅛ × 2⅝ in.

9. Miphra, 2008. Acrylic on canvas over wood, 72⅛ × 45⅛ × 2⅝ in.

10. Priya, Eternal light, 2008. Bronze, 12 × 12 × 8½ in.

11. Lahav VI, 2008. Acrrylic on wood, 7¾ × 8½ × 8½ in.

12. Lahav V, 2008. Acrylic on wood, 5³⁄₁₆ × 6⅛ × 6⅛ in.

13. Lahav IV, 2008. Acrylic on wood, 6¾ × 7¾ × 7¾ in.

14. Quya III variation II, Menorah, 2008. Acrylic on wood, 48½ × 37 × 20 in.

15. Dahka, Charity box, 2008. Acrylic on wood, 49½ × 16¾ × 16¾ in.

16. Ykarh, Havdalah candlestick holder, 2008. Acrylic on wood, 13¾ × 2⅞ × 3⁵⁄₁₆ in. Spice box, acrylic on wood, 4⅜ × 3¾ x 3¼ in.

17. Ykarh II, Havdalah candlestick holder, 2008. Acrylic on wood, 10⅛ × 2¾ × 4⅛ in. Spice box, acrylic on wood, 4⅜ × 3¾ × 3¼ in.

18. Ykarh III, Havdalah candlestick holder, 2008. Acrylic on wood, 10⅛ × 2¾ × 4³⁄₁₆ in. Spice box, acrylic on wood, 4⅜ × 3¾ × 3¾ in.

19. Mezuzot, set of four, 2008. Acrylic on wood, dimensions vary.

20. Zohaar, Shabbat candle holders, 2008. Acrylic on wood, 13⅝ × 5⅞ × 5⅞ in. each.

21. Ohrenh II, Torah breastplate, 2009. Acrylic on wood, 10⁹⁄₁₆ × 8½ × 1¾ in.

22. Ohrenh III, Torah breastplate, 2009. Acrylic on wood, 10⁹⁄₁₆ × 8½ × 1¾ in.

23. Ohrenh IV, Torah breastplate, 2009. Acrylic on wood, 10⁹⁄₁₆ × 8½ × 1¾ in.

24. Saphyr II, Omer counter, 2004. Acrylic on wood, 72⅝ × 58⅝ × 24¹¹⁄₁₆ in.

25. Ahma, Shalom Bat chairs, 2008. Acrylic on wood, each 70⅜ × 20⁷⁄₁₆ × 26⅜ in. Commissioned by Shaykin Family Foundation for the Abraham Joshua Heschel School, New York, NY.

26. Kri'ah, 2009. Acrylic on wood, 55 × 17 × 4½ in. Plaza Jewish Community Chapel.

27. Shuva, 2009. Acrylic on canvas over wood, 20⅛ × 61⅛ × 2¾ in. Plaza Jewish Community Chapel.

28. Ytkha, 2009. Acrylic on wood, 49⅝ × 13½ × 13½ in. Plaza Jewish Community Chapel.

29. Shalev (model), 1994. Bronze, 8⅛ × 6 × 3¾ in.

30. Emet, Meditative space (model for HealthCare Chaplaincy, New York, NY), 2001. Acrylic, canvas and wood.

Jeff Edwards is a master's candidate in the Department of Art Criticism and Writing at the School of Visual Arts in NYC and will be teaching at SVA in the spring of 2010.

Ena G. Heller is founding Director of MOBIA. An expert in art and religion, she has edited the volumes *Icons or Portraits?* (2002) and *Reluctant Partners* (2004), and has published in the field of medieval art (in the volume *Women's Space*, 2005) and biblical studies (in *From the Margins I: Women of the Hebrew Bible*, 2009).

David Morgan is Professor of Religion at Duke University. Author of several books, including *Visual Piety* (1998), *The Sacred Gaze* (2005), and *The Lure of Images* (2007), he is also an editor of the journal *Material Religion*.

Klaus Ottmann is Robert Lehman Curator at the Parrish Art Museum in Southampton, NY, and an independent scholar based in New York City. Among his books are *Color Symbolism: the Eranos Lectures* (2005); *The Human Argument: the Writings of Agnes Denes* (2007); and *The Inward Eye: Transcendence in Contemporary Art* (2002).

Nessa Rapoport is a novelist *(Preparing for Sabbath*, 1981*)* and a poet *(A Woman's Book of Grieving*, 1994*)*. With Ted Solotaroff, she is editor of *The Schocken Book of Contemporary Jewish Fiction* (1996). Her most recent book is *House on the River: A Summer Journey* (2004).

Daniel Sperber is the Milan Roven Professor of Talmud and President of the Ludwig and Erica Jesselson Institute for Advanced Torah Studies at Bar-Ilan University in Israel, a recipient of the Israel Prize, and an expert in classical philology, history of Jewish customs, Jewish art history and Jewish education. His most recent book is *The Jewish Life Cycle: Custom, Lore and Iconography* (2008).